WORLD FILM LOCATIONS NEW YORK

Edited by Scott Jordan Harris

First Published in the UK in 2011 by Intellect Books, The Mill, Parnall Road, Fishponds, Bristol, BS16 3JG, UK

First Published in the USA in 2011 by Intellect Books, The University of Chicago Press, 1427 E. 60th Street, Chicago, IL 60637, USA

Reprinted in 2012

Cover photo: United Artists / The Kobal Collection / Hamill, Brian

Copy Editor: Emma Rhys

Intern Support: Judith Pearson, Carly Spencer and Hannah Evans

A Catalogue record for this book is available from the British Library

World Film Locations Series
ISSN: 2045-9009
eISSN: 2045-9017

World Film Locations New York
ISBN: 978-1-84150-482-7
eISBN: 978-1-84150-530-5

Printed and bound by Bell & Bain Limited, Glasgow

WORLD FILM LOCATIONS NEW YORK

EDITOR
Scott Jordan Harris

SERIES EDITOR & DESIGN
Gabriel Solomons

DESIGN ASSISTANT
Persephone Coelho

CONTRIBUTORS
Samira Ahmed
John Berra
Jez Conolly
David Finkle
Peter Hoskin
Wael Khairy
Simon Kinnear
Michael Mirasol
Neil Mitchell
Omar P.L. Moore
Omer M. Mozaffar
Elisabeth Rappe
Emma Simmonds
Grace Wang

LOCATION PHOTOGRAPHY
Gabriel Solomons
(unless otherwise credited)

LOCATION MAPS
Joel Keightley

PUBLISHED BY
Intellect
The Mill, Parnall Road,
Fishponds, Bristol, BS16 3JG, UK
T: +44 (0) 117 9589910
F: +44 (0) 117 9589911
E: info@intellectbooks.com

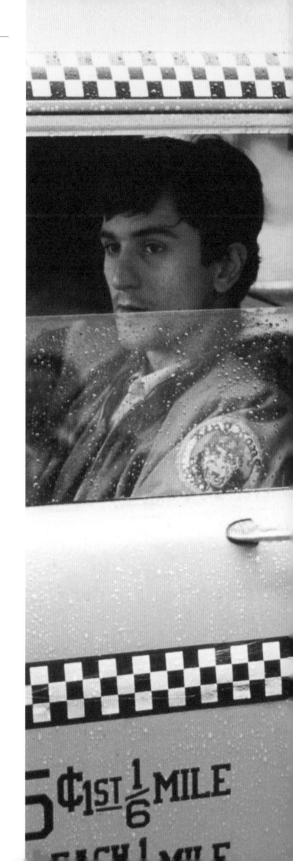

CONTENTS

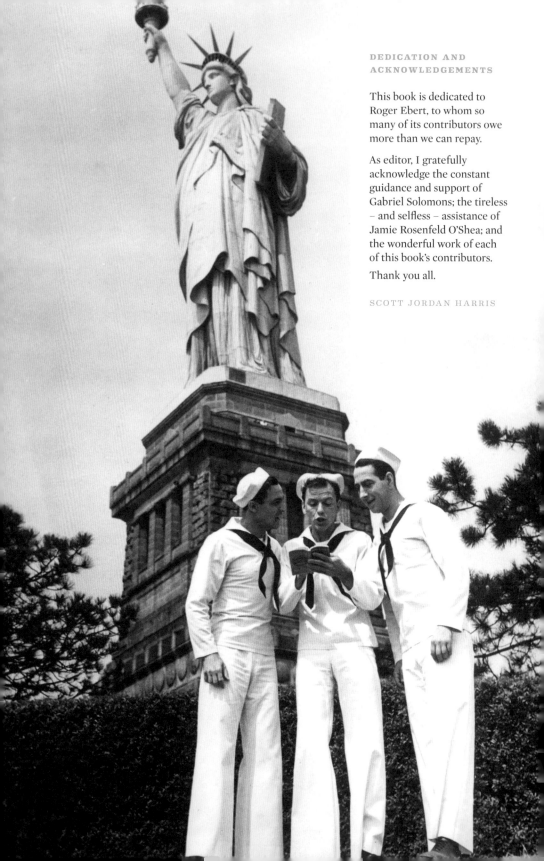

DEDICATION AND ACKNOWLEDGEMENTS

This book is dedicated to Roger Ebert, to whom so many of its contributors owe more than we can repay.

As editor, I gratefully acknowledge the constant guidance and support of Gabriel Solomons; the tireless – and selfless – assistance of Jamie Rosenfeld O'Shea; and the wonderful work of each of this book's contributors.

Thank you all.

SCOTT JORDAN HARRIS

INTRODUCTION

World Film Locations New York

WRITING THE FOREWORD to Roger Ebert's *The Great Movies*, Mary Corliss – assistant curator at the Department of Film and Media at New York's Museum of Modern Art – concluded 'still photos show [...] just how moving moving pictures can be.' This sums up much of our approach to the World Film Locations series. The pictures used in these books draw and hold the eye, and express the point of our articles as much as the words. We realise that writing about film without employing well-chosen images is like discussing music in mime.

World Film Locations explores the city on-screen. And the city explored in this volume is perhaps the most storied, photographed and – of course – filmed on earth. A capital of culture, finance, politics and business, an entry point for immigrants, an empire for crime lords and, subsequently, the setting for a multitude of movies, New York is a uniquely cinematic city. Our aim is to capture some of its appeal in these pages, via the work of those who have captured it on film.

This book is not a completist's list of film locations or an exhaustive examination of film-making in New York; short of an encyclopaedia, no book could even record every film, let alone every film scene, shot in the city. Nor is the book a travel guide, though it could function as one, whether film fans use it to tour New York on foot or in the imagination.

This volume collects 44 reviews of 44 scenes from 44 films, each shot – at least in part – in New York. The pieces are illustrated by images from the scene in question and photographs of its location, often as it is today. Together, the words and images expose the relationship between a scene's setting and its impact on the viewer. Frequently, too, they expose the relationship between a memorable scene and the impression it has given us of its setting: so often, of course, our first thoughts of a famous location are of its appearances on-screen. Some of the backdrops discussed here – the World Trade Center's Twin Towers most obviously and most movingly – no longer exist. Others, like the Statue of Liberty, stand as they have always stood. And still others, like Coney Island, exist today but in a drastically different way than we are used to seeing on the cinema screen.

The short scene reviews are interspersed with essays. One of these discusses the place New York occupies in the imaginations of moviemakers and moviegoers. Two others examine the respective relationships Woody Allen and Martin Scorsese – so often the light and dark of New York film-making – have with their home city. Others examine landmarks, film-making movements, or trends that dominate the history of NYC on-screen.

Taken as a whole, this book is an examination of film-making freed from the blue screen and the back lot – and a compendium of some of the most unforgettable scenes ever shot in New York. But more than this it is, we hope, a fitting celebration of the Big Apple on the big screen. ✤

Scott Jordan Harris, Editor

NEW YORK

City of the Imagination

Text by
DAVID
FINKLE

NEW YORK CITY IS PHOTOGENIC.
Of course, it is. As one of the world's greatest cities – some would say the absolute greatest – it is intrinsically photogenic. As a five borough city crammed with people and their stories, and chockablock with actors, writers, producer, directors and designers ready to observe, react to, record and interpret these stories, New York City would, by sheer numbers, have to be photogenic. As a centre of arts, commerce and industry, it would de facto be photogenic. So what if the city's industries are shrinking in the early part of the twenty-first century? The fashion industry continues to thrive – and the models populating it are certainly photogenic.

The sprawling, brawling, bawling, crawling, galling, mauling, appalling, enthralling metropolis is one of the most obvious locations for movies to be made and movies to be about – and has been for well over 100 years. And this is true even though, for many decades in

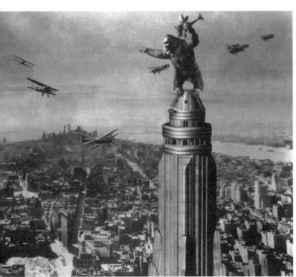

the middle of the twentieth century, movies about New York City were filmed on Hollywood back lots, on the studios' standard New York City brownstone-lined thoroughfares, and frequently underscored by the sweeping theme Alfred Newman composed for King Vidor's 1931 *Street Scene*. Does anyone have to ask where the scenes on that *Street Scene* street are located? No, is the correct answer. Does any other city on the planet have as recognizable a theme riff? Possibly 'Hooray for Hollywood' for Hollywood or the George Gershwin's *American in Paris* themes for Paris, but, really, no is again the correct answer.

Mention New York City to moviegoers and instantly their heads fill with footage. Minds are aglow with endless images of scenes set in the city. Many of them will be mentioned in great detail throughout the book you're holding and don't need to be enumerated here. But it's still instructive to list some of those locations: Wall Street, Broadway, the Brooklyn Bridge, JFK and LaGuardia airports, Staten Island, the Statue of Liberty, Battery Park, the United Nations (which is admittedly on international territory within the City), Central Park, the East River, the Hudson River, Astoria, Fifth Avenue, Madison Avenue, Greenwich Village, the Upper West Side, the Upper East Side, Harlem, the Staten Island Ferry, the Waldorf-Astoria, the Plaza, Macy's, Tiffany's, the Empire State Building, the Twin Towers... you name the venerable, ballyhooed landmark and mental images from film tumble over one another, crowd one another out, compete for attention.

The reason is clear: New York, as much or more than any city in the world, is a melting pot. It's a crucible. Just about anything that can happen to man, woman or child happens in New York City and perhaps with even greater intensity. Look at any film genre and

New York City – where what remains of some Hollywood studios still base their business offices – is a repeated character.

Big city romances? What big star hasn't locked lips with another big star in the Big Apple? Comedies? Obviously. Family dramas? Definitely. Mysteries? Of course. Even Westerns! How many police procedurals adhering to the plot structure of Westerns have been shot in the five boroughs?

And there is one genre that sometimes seems as if it couldn't exist without New York City, sitting there with its bare, tempting, vulnerable cityscape hanging out: the end-of-the-world film. In how many movies is New York City under attack? In how many is it being escaped from? In how many is the Statue of Liberty shown having her head decapitated or lying in pieces or buried under leagues of sand or water? In how many crowd scenes are New York citizens and tourists fleeing on foot while a monster of one sort or another crushes the unfortunate? How many metal shards come hurtling towards the camera from blasted cars that minutes before were innocently negotiating New York City streets or blithely parked at New York City curbs? The answer to all is: too many to count.

It's hard to imagine a time when New York City ceases to be the apotheosis of the city on film. Certainly, the City's government doesn't want the eyes of the world to stop watching. An especially significant reason why NYC is a moviemaking Mecca is its support system for the industry. Just start with the six-soundstage Kaufman Astoria Studios. Beyond that, the Mayor's Office of Film, Theatre & Broadcasting – aware that the hefty revenues involved indicate this is another local industry not shrinking – has for quite some time been easing the stresses on on-location filming.

The result is that there's hardly a native or adopted New Yorker who hasn't watched a movie being filmed on his or her block and, as a result, hasn't felt a part of the never-ending process of New York film-making. As far as New Yorkers are concerned, they're all in the movie business. For movies about New York City – bless its airy highs and asphyxiated lows! – it seems unlikely there will ever be a final fade out. ✛

Mention New York City to moviegoers and instantly their heads fill with footage. Minds are aglow with endless images of scenes set in the city.

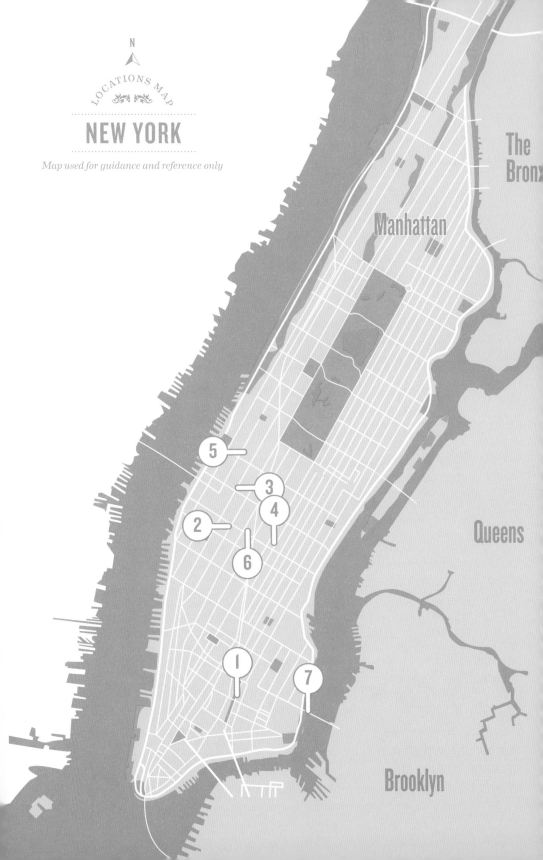

LOCATIONS MAP

NEW YORK

Map used for guidance and reference only

The Bronx

Manhattan

Queens

Brooklyn

5

3

4

2

6

1

7

NEW YORK LOCATIONS

SCENES 1-7

THE JAZZ SINGER (1927)

Hester and Orchard Streets, Lower East Side, Manhattan

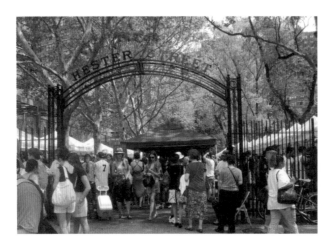

THE JAZZ SINGER is frequently recalled as the first 'talkie', heralding the ascendance of synchronized dialogue in movies, and the decline of silent film. But what many forget is how it remains a pointed and poignant parable about an immigrant's heritage. It takes on issues of bigotry, Jewish identity and commitment to artistry: subjects of great consequence when it was released that are no less important today. A great many scenes in the film help enrich these themes, and its very first ones are no exception, as it begins with shots overlooking the Jewish ghetto in the Lower East Side of Manhattan. To view them today is to appreciate one of filmdom's great gifts, which is to serve as a time machine. We see the streets of Hester and Orchard overflowing with people. Pushcarts, shaded stalls and goods sold left and right. A makeshift merry-go-round so packed with children that sardines would complain. Horse-drawn carriages are the way things get around, and housewives crowd the roads to get what they need. It all looks positively Dickensian. Who knows what audiences back then thought of these scenes? Perhaps they were not as in awe as we would be due to the disparity of the times but, just maybe, they were held rapt to some of these very first scenes of the city. Their images helped define what people thought of New York back then – very different from what we think of today. **❖Michael Mirasol**

Above Hester Street open air market (Photo © Jean Hsu)

Directed by Alan Crosland
Scene description: Our first sight of the New York ghetto
Timecode for scene: 0:00:20 – 0:01:17

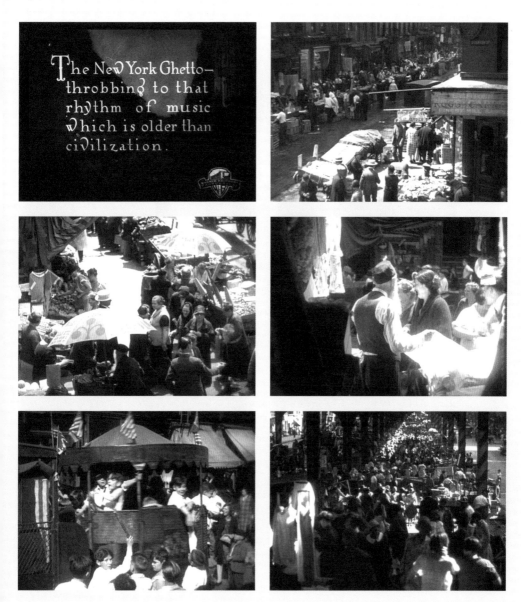

The New York Ghetto—
throbbing to that
rhythm of music
which is older than
civilization.

SPEEDY (1929)

LOCATION *Outside Pennsylvania Station, Seventh and Eighth Avenue, between 31st Street & 33rd Street, Manhattan*

FILMED LARGELY on location – and featuring two living landmarks in baseball players Babe Ruth and Lou 'The Pride of the Yankees' Gehrig – Harold Lloyd's last silent comedy is one of the great New York films, its importance and appeal only enhanced because it celebrates an NYC that no longer exists: a pre-skyscraper city of trams and horse cars (or rather, a single horse car – the last in operation). One of its funniest scenes sees Lloyd's eponymous character, Harold 'Speedy' Swift, living up to his nickname when, apparently promising him his first ever fare as a taxi driver, two men jump into his cab and shout, 'Pennsylvania Station – and step on it!' Rushing through (now gloriously archaic) New York streets, Speedy's (now gloriously archaic) cab is seen by a policeman, who gives chase on his (now gloriously archaic) motorcycle. Arriving outside Penn Station, Speedy asks his passengers for payment, and is instead shown two police badges. The officers are in search of a suspect and dash inside. The motorcycle cop catches up and, inevitably, hilarity follows. The pillars of Penn Station visible here are, despite the extensive renovations that have taken place at the station since the 1920s, still recognisably those that stand today. The building and vehicles and people and city that surround them, however, are now of another age. Seeing Penn Station in *Speedy* and then seeing it as it is in the twenty-first century feels like looking at a man's baby pictures and then attending his 100th birthday.
❥ Scott Jordan Harris

Above Entrance to Pennsylvania Staion (Photo © Rickyrab)

Directed by Ted Wilde
Scene description: 'Pennsylvania Station – and step on it!'
Timecode for scene: 0:45:10 – 0:47:02

Images © 1928 The Harold Lloyd Corporation

42ND STREET (1933)

An exaggerated, stage version of 42nd Street, Manhattan

WELCOME TO 42ND STREET, New York, Philadelphia. Yes, Philadelphia. For that is where the demands of American theatre have swept director Julian Marsh (Warner Baxter) and his troupe for the opening night of their latest show. After mishap, misunderstanding, one broken ankle and several broken hearts, the stage is set for the final dance number. And the set just happens to be an artistic reconstruction of New York's 42nd Street, right down to its subways and fruit stands. In the background, a matte painting trails off towards a false horizon. Which would add up to very little were it not for the great Busby Berkeley's choreography. Dancers dressed as cops, clerks, newspaper boys, bums, dandies, gangsters and molls sashay across the screen, in a lively vignette of New York life. A police horse lifts its hooves in time with the beat. Cars whizz past from nowhere. And by now the stage seems to have swollen beyond its original confines and beyond the confines, too, of dull, everyday logic. Marsh has delivered the extravaganza he promised. This one's going to be a smash. It is a wonderfully optimistic end to a film that hasn't previously shied away from the harsh realities of Depression-era America. As the camera swoops in towards Ruby Keeler and Dick Powell's pair of lovers, the abiding message is this: there's always a reason to tap your feet.
➼ *Peter Hoskin*

Above 42nd Street between 7th and 8th Avenues (Photo © Quadell)

Directed by Lloyd Bacon
Scene description: *The big dance number from 42nd Street*
Timecode for scene: *1:22:16 – 1:28:04*

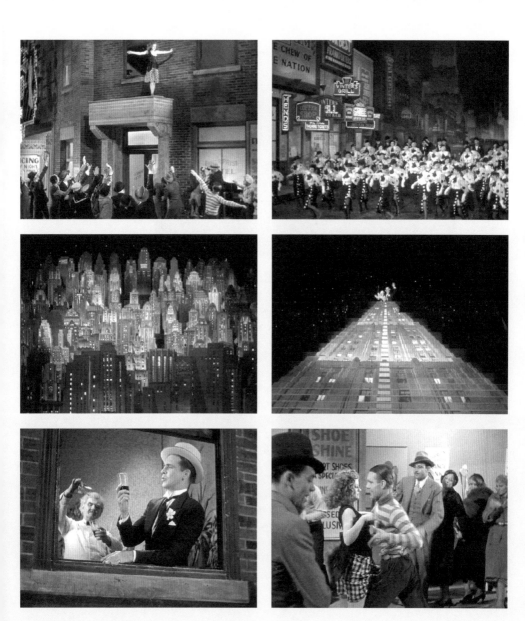

Images © 1933 Warner Bros. Pictures

KING KONG (1933)

The Empire State Building, 350 Fifth Avenue (in model form), Manhattan

THE POSTERS for *King Kong* never quite got it right. What they show, on the whole, is a devil ape with malice in its eyes. Yet by the time Willis O'Brien's stop motion creature begins his climb up the Empire State Building, we know that there's little real malice in him at all. Kong is an animal, plain and simple. And one who is taken away from his home, cast into chains, and subjected to the gasps and bursting camera bulbs of Broadway. His escape into New York City is destructive and deadly – but he never should have been there in the first place. If this is what lends *King Kong*'s finale its tragedy, it also lends it a subversive sort of humour. The Empire State Building had opened less than two years before the film premiered. It was one of the modern world's most emphatic achievements. Yet here it was being clambered all over by a gigantic, primeval gorilla. There are few, if any, more delightfully preposterous scenes of Old versus New in all of cinema. And, in this case at least, we are guided into siding with the Old. Human progress may have brought us the glittering towers of New York, but it also delivered the planes and guns that killed Kong. And, oh yes, it was the planes and guns that killed Kong. When Robert Armstrong's Carl Denham says at the end – 'It was beauty killed the beast' – that's just a get-out clause. ••*Peter Hoskin*

(Photo © Andrew Shiue)

Directed by Merian C. Cooper and Ernest B. Schoedsack
Scene description: King Kong ascends the Empire State Building
Timecode for scene: 1:37:42 – 1:43:52

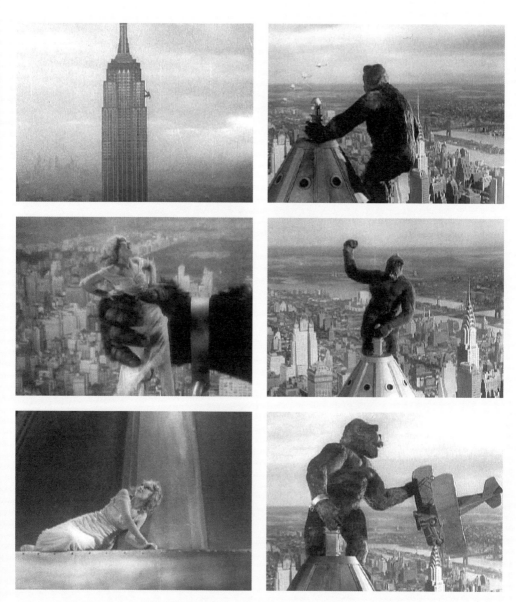

Images © 1933 RKO Radio Pictures

THE LOST WEEKEND (1945)

LOCATION

13 West 52nd Street, Manhattan

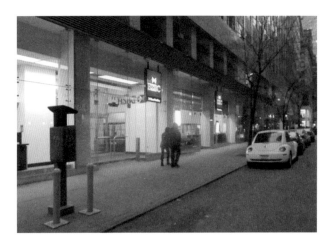

BILLY WILDER'S stark and sorrowful drama, based on a novel by Charles R. Jackson, charts the spiralling degeneracy of failed scribbler and desperate dipsomaniac, Don Birnam (the Oscar-winning Ray Milland). After an abortive attempt at writing turns into a frantic hunt for liquor, Don spots a discarded matchbook advertising 'Harry & Joe's, 13 West 52nd St, NY'. When we next see him, he is seated in the aforementioned bar, requesting the cheque. Unable to pay in full, he instead orders another drink and, in desperation, swipes the clutch-bag of the woman seated beside him. Don retires to the washroom, where he removes the required $10 to cover his bill, inserting a carnation in its place. When he returns to the scene, he is confronted by the couple and the bar staff in an excruciating public humiliation. As he is removed from the premises, howling 'I'm not a thief,' the piano player strikes up with 'Somebody Stole a Purse' (to the tune of the popular song 'Somebody Stole My Gal') and the assembled crowd cheerfully sing along. As well as representing a particularly sorry episode in Don's breakdown, and further stripping away the glamour of boozing (a consequence-free staple of Hollywood films of the era), the sequence shows us the blasé reaction of New Yorkers to the crime – showing them collectively as sassy and irreverent urbanites, inured to such delinquency. ➔*Emma Simmonds*

Directed by Billy Wilder
Scene description: Don's humiliation in Harry & Joe's Bar
Timecode for scene: 0:53:34 – 0:57:26

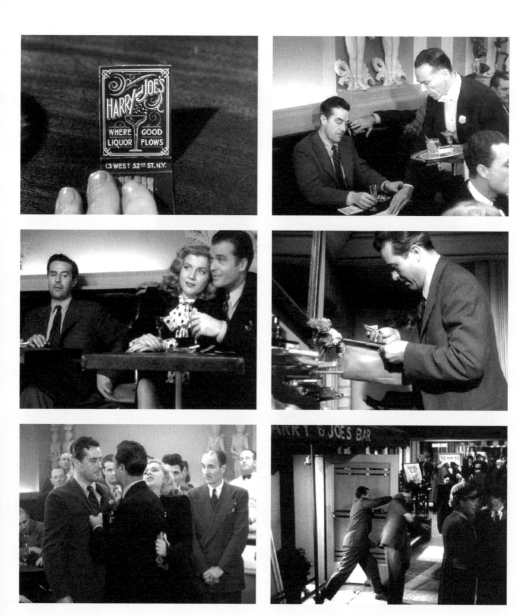

Images © 1945 Paramount Pictures

MIRACLE ON 34TH STREET (1947)

LOCATION *77th Street, heading south to 151 West 34th Street, Manhattan*

THIS CLASSIC YULETIDE story of a Manhattan department store Santa put on trial when he claims to be the real thing has been re-made several times. However, the 1947 original remains definitive, not least because of its copious location filming. George Seaton's film thrives on rooting its fantasy in the everyday world, the story revolving around Macy's flagship store on 151 West 34th Street. In addition to filming several sequences inside the store, Seaton's bid for authenticity saw him take cast and crew to the actual Macy's Thanksgiving Parade in 1946. The film begins with Kris Kringle (Edmund Gwenn) discovering that the actor due to play Santa is inebriated. When parade organiser Susan Walker (Maureen O'Hara) spots Kringle's white beard and kindly demeanour, she hires him on the spot to replace the drunk. Macy's allowed Seaton to shoot Gwenn and O'Hara as the floats were being set up on 77th Street, with the caveat that the parade wouldn't wait if the scene wasn't in the can. Gwenn then took the reins of Santa's sleigh and rode on the float to 34th Street. The documentary-style footage of him wowing the crowds is the real deal, not least because nobody knew 'Santa's' secret identity, as Gwenn's participation wasn't promoted until after the parade. By 1994, such co-operation was a thing of the past. Macy's refused permission for its name to be used in the remake starring Richard Attenborough, removing much of the film's verisimilitude – and the geographic specificity of its title.
•❖Simon Kinnear

Above Macy's, 151 West 34th Street

Directed by George Seaton
Scene description: The Thanksgiving Day Parade
Timecode for scene: 0:03:00 – 0:07:31

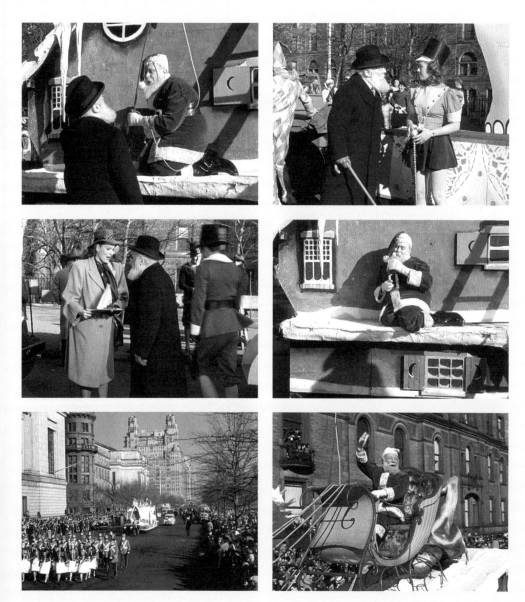

THE NAKED CITY (1948)

LOCATION

*Williamsburg Bridge at Delancey Street (Manhattan)
and Grand Street (Brooklyn)*

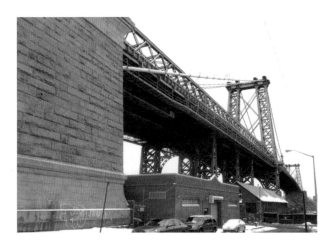

THE NAKED CITY was shot on location – and how. Jules Dassin's 1948 crime flick sprawls out over New York: winding through its streets, capturing its people, and trudging through its underworld. It's no surprise that this one was produced by the former newspaperman Mark Hellinger. Nor that the photojournalist Weegee (Arthur Fellig) was an on-set consultant. The whole thing has a documentary feel that was rare for a fiction film at the time. It still is now. The film saves its most bravura location shooting for its climax: a chase across the Williamsburg Bridge. Out ahead, the murderer Garzah (Ted de Corsia, a child of Brooklyn). Behind him, the persistent foot soldiers of the NYPD. Gunshots are traded, and Garzah – bleeding, sweating and beat – drags himself up into the steel innards of the bridge. The East River dozes below. Central Park sits, unreachable, in the distance. It is in these moments that *The Naked City* starts to play more like a film noir than a standard police procedural. The wires and struts of the bridge slice across the screen like prison bars. Its stairways come to an unforgiving dead end. As Garzah's body plummets inevitably to earth, Dassin's camera dwells on the New York skyline, unmoving and unmoved. In the end – after all that – this city couldn't care less. ⇝***Peter Hoskin***

Directed by Jules Dassin
Scene description: Chase across the Williamsburg Bridge
Timecode for scene: 1:28:36 – 1:33:30

Images © 1948 Hellinger Productions; Universal International Pictures

NEW YORK'S LEADING LADY

The Statue of Liberty on Film

Text by
SIMON
KINNEAR

A BASTION OF FREEDOM, she welcomes newcomers to America with a book of law in one hand while, in the other, a flaming torch wards off potential aggressors. The central dichotomy of the Statue of Liberty has made her one of the most iconic landmarks in cinema; at once an inspiration to immigrants and a target for dystopian violence.

To some extent, the birth of 'Liberty Enlightening the World' (the Statue's full name) coincides with that of cinema. Devised in 1865 as a gift to commemorate France's shared history of revolution with America, she was built by Frédéric Bartholdi throughout the 1870s and officially dedicated in 1886, arriving in time for the new medium pioneered – with apt symmetry – by one American and two Frenchmen – Thomas Edison and the Lumière Brothers. It was Edison's flickering minute-long film of the Statue (1898) that helped propel Liberty's mystique across America and beyond.

From the start, Liberty symbolised a safe haven, exemplified in Emma Lazarus' sonnet 'The New Colossus': 'Give me your tired,

your poor / Your huddled masses yearning to breathe free / The wretched refuse of your teeming shore.' Lazarus's famous words provide film-makers with a potent image. Liberty was the first sighting of America for ambitious gangster Vito Corleone (Robert De Niro) in *The Godfather Part II* (Ford Coppola, 1974); and, far more bittersweet, for survivor Rose DeWitt Bukater (Kate Winslet) in *Titanic* (Cameron, 1997). Charlie Chaplin's *The Immigrant* (1917) satirised the harsh realities behind the Statue's promise for penniless new arrivals. In Jewish refugee allegory, *An American Tail* (Bluth, 1986), mouse hero Fievel's first encounter on American soil is with a French pigeon who claims to be the Statue's architect.

Remarkably, the latter is Hollywood's closest approximation of a biopic about the Statue's creation – unless you count Phileas Fogg (Steve Coogan) getting into a muddle with Liberty's unattached head in *Around The World in 80 Days* (Coraci, 2004). That, at least, is historically accurate. New York's first glimpse of Liberty was of her fractured anatomy: the arm, for instance, was displayed in Madison Square Park between 1876 and 1882. Considering the cinematic carnage inflicted on the Statue, it's tempting to wonder if that memory has ever really faded. Add to that that Liberty Island once housed an army base, Fort Wood, and the subtext becomes irresistible: what can be created can be destroyed.

Although a tsunami in 1933's *Deluge* (dir. Feist) wrought the first major cinematic attack on Liberty, it was Alfred Hitchcock – at the height of the Second World War – who first seized on the Statue's symbolic value. The climax of *Saboteur* (1942) sees wrongly accused Barry Kane (Robert Cummings) chase the actual culprit (Norman Lloyd) onto Liberty's hand, where the villain falls to his death. Arguably, the Statue is little more

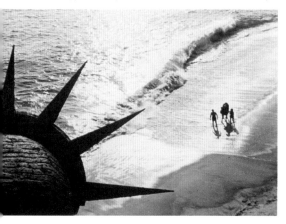

John Carpenter underlined his dystopian nightmare by making Liberty Island the headquarters of New York's totalitarian authorities.

Nowadays, with sci-fi spectacle a central element of the Hollywood blockbuster, it is more surprising if Liberty isn't destroyed. Part of the shift owes to the availability of state-of-the-art special effects that can convincingly visualise the Statue's downfall. But there's a more evocative reason for its repeated destruction over the past quarter-century. In 1984, a highly public restoration – which saw Liberty enveloped in scaffolding – laid bare the Statue's fragility. *Remo Williams: The Adventure Begins* (Hamilton, 1985) even staged a fight scene on the scaffolding.

The floodgates were open – literally. Liberty has been toppled by tides in *Deep Impact* (Leder, 1998) and *2012* (Emmerich, 2009); submerged by rising seas in *A.I. Artificial Intelligence* (Spielberg, 2001); frozen in *The Day After Tomorrow* (Emmerich, 2004). And don't forget the aliens: both *Independence Day* (Emmerich, 1996) and *Cloverfield* (Reeves, 2008) brought malevolent invaders to New York to attack the landmark. (Special mention must go to Roland Emmerich, the auteur of apocalypse, who directed three of the above films.)

In modern movies, it takes super-heroic effort to protect America's Liberty: both *Superman IV* (Furie, 1987) and *X-Men* (Singer, 2000) feature set-piece battles on the Statue. Some fantasies go further by actually enlisting Liberty's help. In *Men in Black 2* (Sonnenfeld, 2002), it is revealed that the Statue houses an extra-terrestrial defence system; while in *Ghostbusters II* (Reitman, 1989) supernatural slime enables Liberty to walk Manhattan's streets to unite its residents.

For Fievel, Vito Corleone and Thomas Edison, pioneers in a new world, it was enough simply to gaze in wonder at the Statue of Liberty. Arguably, it still is. What else is the contemporary emphasis on chaos but a reminder that America considers liberty to be its greatest export? Long before September 11 added cruel resonance to the imagery, Hollywood has asserted the Statue's values by daring to imagine an America without her – to show that, no matter how often moviemakers decapitate, drown or destroy her, in real life she still stands proud. ✦

than a backdrop for suspense, but Hitchcock's cheeky inference was clear. His surreal studio mock-up of Liberty, emphasising her looming features, drew the thinnest of lines between sanctuary and sadism.

Liberty survived the war, but it was around this time that science fiction writers began to dabble seriously with the prospect that she might be threatened, if not by Nazism then by nuclear holocaust. This sudden, sustained portrayal of devastation led Robert Holdstock to declare in 1979, 'Where would [science fiction] be without the Statue of Liberty? [...] The symbol of Liberty, of optimism, has become a symbol of science fiction's pessimistic view of the future.'

By then, Hollywood had pulled off the most striking visual coup of all: an allegorical reflection on the counter-cultural upheavals of 1968. Marooned on the *Planet of the Apes* (dir. Schaffner), Charlton Heston's astronaut makes his escape, only to realise the futility of his effort when the camera pulls back to reveal Liberty, half-buried in the sand on a future earth.

So totemic was the depiction of Lady Liberty in Planet of the Apes that, for many years, it stood alone. Even *Escape From New York*'s (1981) eye-catching poster image of Liberty's head lying in a Manhattan street didn't actually appear in the film, although

> **...The symbol of Liberty, of optimism, has become a symbol of science fiction's pessimistic view of the future.**

NEW YORK LOCATIONS

SCENES 8-14

ON THE TOWN (1949)

LOCATION *Brooklyn Navy Yard, Brooklyn*

THE *SINE QUA NON* New York City movie is perhaps the 1949 MGM musical *On The Town*, with singer-dancers Gene Kelly, Frank Sinatra, Vera Ellen, Ann Miller, Betty Garrett and Jules Munshin. This is the film adapted from the 1944 Broadway hit featuring the Leonard Bernstein-Adolph Green-Betty Comden song, 'New York, New York', and its declaration that the city in question is 'a helluva town'. Because the beloved work is such a valentine to the big time burg, Kelly and Stanley Donen, who co-directed the film, insisted on location filming. Anything else would have been blasphemous. As a result, movie history was changed. The production confirmed that shooting exclusively on studio lots was a thing of the past. *On the Town* isn't the first movie to take advantage of the actual city, but it's unquestionably the most seminal. During the opening sequence, in which lyricists Comden and Green (proud New Yorkers) mention the plethora of must-see spots and Sinatra sings, 'I wouldn't miss 'em, any,' Kelly and Donen provide an exhilarating on-the-town tour, including (but not restricted to) views of Wall Street, the Statue of Liberty, Chinatown, the Empire State Building, Washington Square, Central Park, Rockefeller Center and the Brooklyn Navy Yards, where the adventurous threesome start and finish their 24-hour sailors-on-leave romp. Not to mention that when Kelly's character Gabe locates the girl of his dreams, Ivy Smith, after seeing her image on a poster, she's in a Carnegie Hall rehearsal room. **•*David Finkle***

(Photo © Jake Dobkin)

Directed by Stanley Donen and Gene Kelly
Scene decription: 'A helluva town'
Timecode for scene: 0:01:50 – 0:06:20

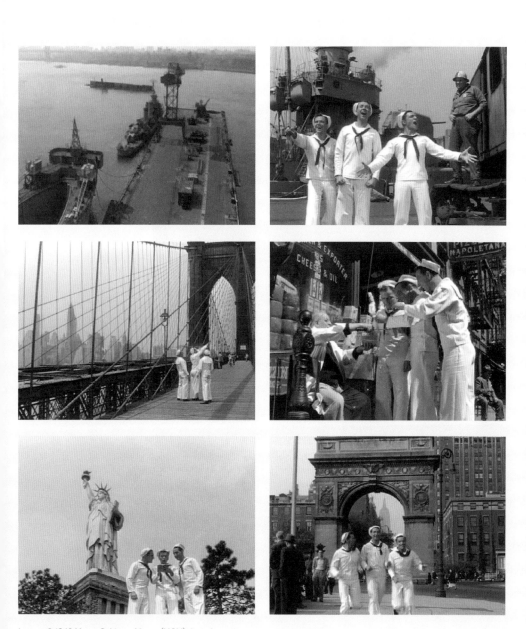

IT SHOULD HAPPEN TO YOU (1952)

LOCATION *Columbus Circle, Manhattan*

LONG BEFORE Andy Warhol promised everybody '15 minutes of fame', and some time before the phrase 'famous for being famous' was bandied about, writer-director Garson Kanin saw the trouble that a hunger for attention could cause – especially in the United States, where it often seems as if fame is guaranteed by the Constitution and therefore every citizen feels entitled to it. So, the master craftsman created the Judy Holliday-Peter Lawford-Jack Lemmon feature, *It Should Happen to You*. Losing her job as a model is the alliterative Gladys Glover, who, by the way, bears some resemblance to Kanin's Billy Dawn of *Born Yesterday* (1950); a role for which Holliday won the Oscar when she repeated her stage triumph on celluloid. To buck herself up for the confidence lost, Gladys decides to emblazon her name on billboards around Manhattan, arguably the nation's status-conferring hub. It's against the background of New York City as 'Fame Central' – represented literally, for instance, on Columbus Circle, where one of the ambitious lady's billboards trumpets her name – that the romantic comedy plays out. In the film, Gladys motors around that site with Lawford's Evan Adams III in order to impress him and, more importantly, herself. It could be said that as an examination of fame's foolishness, the mildly successful comedy is before its time, but nothing this non-stop amusing should be considered premature. Added trivia: Kanin lived on Central Park South and could see Columbus Circle from his windows – or, by extrapolation, could have been someone regularly exposed to Glover's loopy self-aggrandizement. **David Finkle**

Directed by George Cukor
Scene description: The fame game
Timecode for scene: 0:45:56 – 0:48:51

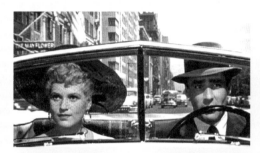
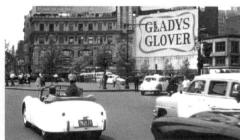
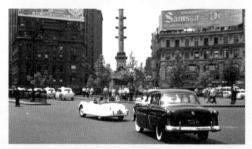
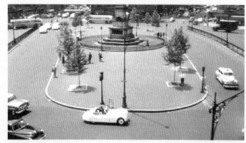
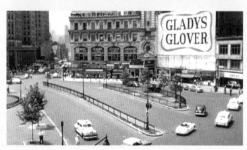
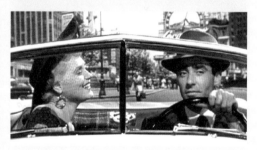

Images © 1954 Columbia Pictures Corporation

THE BEST OF EVERYTHING (1959)

Seagram Building - 375 Park Avenue, Manhattan

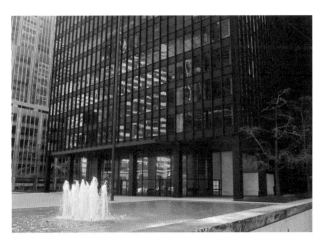

DAWN BREAKS over a glittering, pre-feminist magical kingdom – pink ribbon letters spell out the credits over the tall glinting phallic towers of the Empire State Building and 230 Park Avenue – the street where our Radcliffe-educated, Connecticut heroine will arrive on her quest for a career in publishing and a husband. Or must she choose? We are looking up at the skyscrapers from the subway entrance, sharing the point of view of the secretaries who are about to ascend. First one, then suddenly a horde emerges in eagerness, from subterranean darkness into the light. Oscar-nominated for costume design, we see the jewel-coloured poodle skirts and hair scarves of our would-be princesses. More are spilling out from buses with hat boxes; outside the UN too, the camera always angled to emphasise the manly towers and the tiny women entering these portals of power. We see Carolyn Bender (Hope Lange) – the out-of-towner wearing a hat and gloves, a sober, even nun-like black dress. The camera pans to mimic her gaze, slowly up the tallest most phallic tower of them all; a large American Flag fluttering proudly at its base. The scrap of an advert in her hand confirms it as 375 Park Avenue; home of the Fabian Publishing Company, promising secretaries 'The Best of Everything.' Great challenges await inside. As a girlfriend will later say: 'Here's to men – bless their clean cut faces and dirty little minds.' **⋙Samira Ahmed**

Directed by John Negulesco
Scene description: On the way to her new job
Timecode for scene: 0:00:20 – 0:03:30

PILLOW TALK (1959)

LOCATION

(Scene was shot in a studio overlooking) Intersection of Fifth Avenue and East 51st Street at Saks and St Patrick's Cathedral, Manhattan

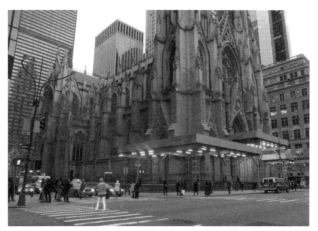

A WISECRACKING sex comedy screenplay from the Mad Men era, this pivotal studio-shot scene in *Pillow Talk* takes place in a high-rise executive office looking down on Fifth Avenue. Tough New Yorker Jan Morrow (Doris Day) has come to deliver some accessories to her interior design client and failed suitor, Jonathan Forbes (Tony Randall). But she reveals she's fallen head over heels in love with a Texan cowboy. The NY neurotic executive feels his Manhattan pride has been hurt. It crackles with Oscar-nominated wit as Jonathan expresses his disgust: 'How could you ever fall in love with a tourist?' Trying to break her dreamy eyed stare, with an appeal to her inner New Yorker, Jonathan leaps to his feet as she sits by the huge window and points down to the intersection of Fifth Avenue and East 51st Street at Saks and St Patrick's Cathedral. (A view suggesting Jonathan's office is possibly in the Rockefeller Centre).

'People jostling, shoving, struggling, milling, fighting for their lives. You're part of it. And even the air. Out there. There's nothing in it but air. New York has air you can sink your teeth into. It has character.'

Jan hasn't been listening; she's clutching a cushion, and he can tell by the look in her eyes that she's lost to him. Jonathan's accepts his defeat, it seems, as he apologises and shows her out. As the sound of cowboy music starts up, the scene is set for her next near encounter with New York playboy, Brad Allen (Rock Hudson): the fake cowboy, who's emerging from the elevator to visit his best friend, Jonathan. ➻ *Samira Ahmed*

Directed by Michael Gordon
Scene description: Jan tells Jonathan she's in love with a mysterious stranger
Timecode for scene: 0:52:24 – 0:54:02

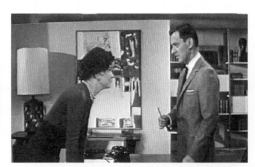 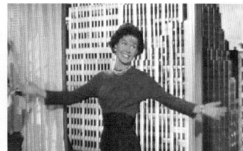

 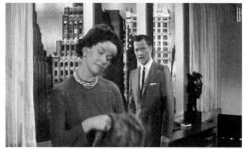

BREAKFAST AT TIFFANY'S (1961)

Outside Tiffany & Co. on 727 Fifth Avenue (at 57th St.), Manhattan

ON A LONG, quiet street in morning light, a yellow taxi glides into view. It pulls to the curb and out steps an elegant woman: black evening gown, long matching gloves and sunglasses, white shawl, a stunning multi-strand pearl necklace adorning her swan-like neck. She strides directly to a store window, opens a white paper bag, retrieves a croissant and coffee, takes a bite and sip, and sighs. It is New York City. This is *Breakfast at Tiffany's*. Audrey Hepburn, suffused with charm, beauty and grace, brought Holly Golightly to life in a way that is unique, often imitated but never replicated. And then, there is 'Moon River', possibly the most perfect song ever written. Full of longing, hope, naïveté and ideals, it speaks of the desire of every young girl who ever dreamt of Prince Charming, and underlines the hip and heartbreaking New York society in the late 1950s. The iconic image of Audrey Hepburn with the one and only Tiffany & Co. has become a staple in the American psyche as the symbol of style, whimsy and romance. It is not about the dress, the pearls, the croissant, the coffee, the little blue box. It is about the freedom, the sweet promise that as morning light breaks, any one of us can pull up beside the place of our dreams and, drifters though we may be, find a moment of refuge from the mean reds that plagued us the long night before. **↝Grace Wang**

(Photos © Nadav Schnall)

Directed by Matthew Turner
Scene description: Holly arrives at Tiffany's
Timecode for scene: 0:00:08 – 0:02:37

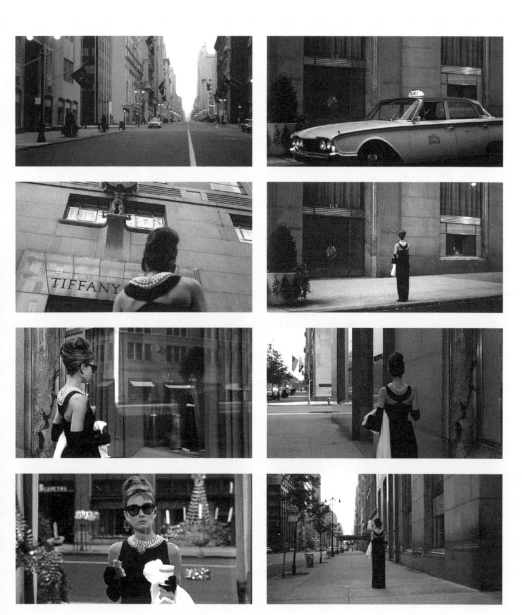

ROSEMARY'S BABY (1968)

LOCATION *The Dakota, 1 West 72nd Street, Manhattan*

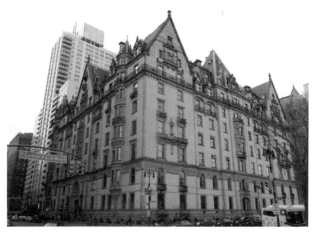

IN ROMAN POLANSKI'S New York-based chiller, Rosemary Woodhouse (Mia Farrow) sees her domestic idyll annihilated by devilry and deception. Rosemary's Baby opens with soft pink credits set against lofty New York panoramas. As the camera drifts drowsily, it is accompanied by Mia Farrow singing a wistful, wordless lullaby. It finally comes to rest on The Bramford, a vast gothic apartment block (actually The Dakota, 1 West 72nd Street) where Rosemary and her husband, Guy (John Cassavetes), are receiving a guided tour. Guy seems twitchy and changeable, and his manner is in contrast to Rosemary's earnest enthusiasm, encouraging us to mistrust him from the outset. The couple are informed by the estate agent, Mr Nicklas (Elisha Cook), that the previous tenant of the apartment they are viewing, an elderly former lawyer, has passed away. As they snoop, Rosemary catches a glimpse of the ominous words, 'I can no longer associate myself,' abruptly ending a letter on the dead woman's desk. A further unsettling sign is that a towering piece of furniture has been improbably moved in order to block off a closet. However, when the wardrobe is pulled away, nothing seemingly untoward is revealed. As Rosemary and Guy walk away from the building, they agree to move in. In *Rosemary's Baby*, Rosemary's happy home turns into a diabolical domestic arrangement, contaminated by the neighbours from hell. The film suggests city-dwellers are better off not knowing their neighbours, and that behind closed doors all manners of wickedness could be taking place. ❖*Emma Simmonds*

Directed by Roman Polanski
Scene description: Rosemary and Guy take a tour of the Bramford
Timecode for scene: 0:00:00 – 0:06:46

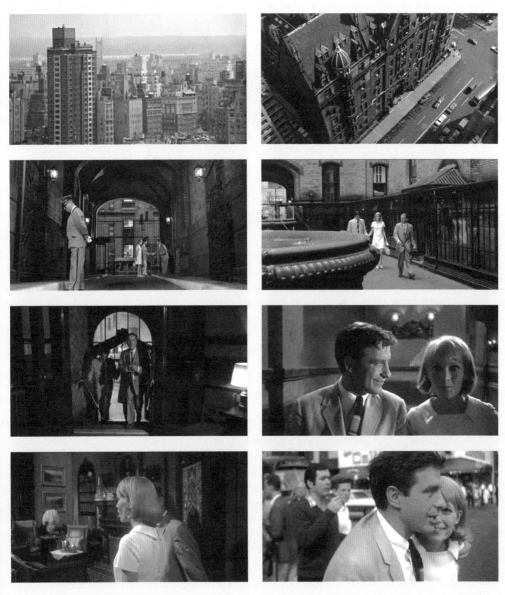

THE FRENCH CONNECTION (1971)

LOCATION *(Subway terminal near) Grand Central Station, Midtown Manhattan*

THE FRENCH CONNECTION uses New York to its fullest. The film teems with memorable scenes and catches a glimpse of virtually the entire city during its darkest period. What people remember is its famed car chase scene. But rarely do we hear about the film's other equally tense sequence: the subway cat and mouse game. A prelude is necessary to appreciate the build-up that leads to it. Two narcs are on the tail of French heroin suppliers who aim to get their product into New York. Lead officer Popeye Doyle (Gene Hackman) splits with his partner to shadow 'Frog One' (Fernando Rey) through the streets of Manhattan. His pursuit is far from a walk in the park as he has to co-ordinate with his fellow officers, as well as make constant misdirection, starts and stops. But the length of his chase, which spills over to the next day in frigid weather, makes him realize he's been made. Not that it deters him. This climaxes in an subway terminal near Grand Central Station, where both Doyle and Frog One display their ingenuity, all to appear obscure despite their awareness of each other. But what shines through all of this is Doyle's dogged determination, which, along with New York, is really the film's centre. ➡**Michael Mirasol**

Directed by William Friedkin
Scene description: Subway cat and mouse
Timecode for scene: 0:56:15 – 0:59:30

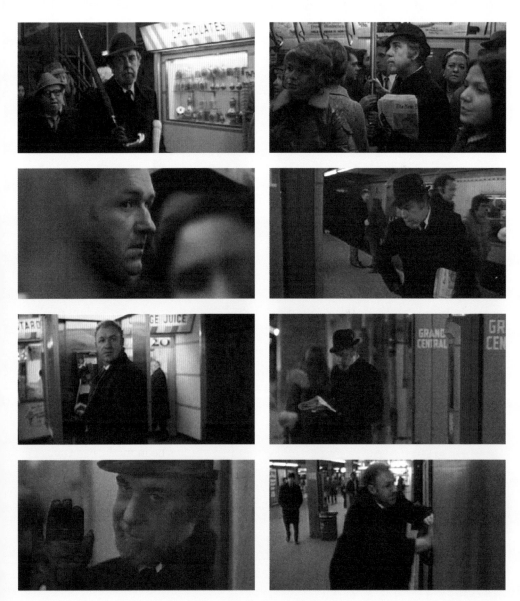

ON THE WATERFRONT

The New York Docks Onscreen

Text by
PETER
HOSKIN

'**THE WATERFRONT OF NEW YORK** – the end of many journeys, the beginning of many adventures.' So reads the title card at the start of Josef von Sternberg's *The Docks of New York* (1928). And so reads the history of New York itself. A natural harbour from the swells of the Atlantic, and split right across by several rivers, this city's most important contours were always going to be those where water met land. It was here where millions upon millions of people disembarked to start a new life in the New World. It was here where America was populated and defined.

So far as cinema is concerned, von Sternberg's film set the tone for future portrayals

of the New York waterfront. Its opening shots of the Twenties riverside are striking enough: all jetties, lumber and debris. But then the director's romanticism swoops in, and casts it all in fog, shadow and intrigue. His main character – a salty, sweaty shipman played by George Bancroft – alights for one night of revelry among the local dives. Yet, before he can reach his first beer den, he happens across Betty Compson's fragile blonde, Mae, attempting to drown herself in the oily waters below. The waterfront may mean new life for the city's immigrants, but for others it spells death and despair.

Bancroft rescues her, of course, and *The Docks of New York* proceeds from there. But the stark realities of waterfront life are always in frame, not least when Mae threatens from her bed, 'I can always make a hole in the water.' It is a sentiment that reverberates throughout the film: this is a dangerous and, in many ways, deadening place to be. The boozers in the bars grope at any woman that walks past. Relationships are fleeting and riven by jealousy. And while – when refracted through von Sternberg's camera – there is a sleazy sort of beauty to all this, there is also horror.

Von Sternberg leavens his film with a redemptive ending – although the redemption is not for the waterfront itself, but for Bancroft and Compson's characters. Something similar may be said of the most famous dock film of them all: Elia Kazan's *On the Waterfront*, released a quarter-century later

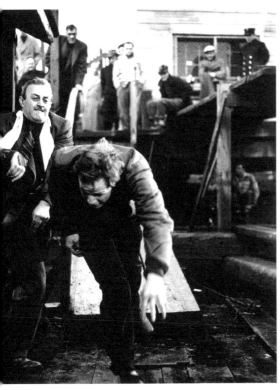

perched above the East River. This hideaway is no doubt intended to symbolise McCoy's isolation, the precariousness of his life, and all that. But it is the sheer look of it that impresses: a hammock strung in the corner, rickety wooden walls, and a box submerged under the water containing the spoils of his thievery. It is a pirate's retreat, in sprawling New York.

As for other noirs that exploit the pirate territory of the waterfront, the list is extensive: from Jules Dassin's journalistic *The Naked City* (1948), to B flicks like *Port of New York* (Benedek, 1949). Although Abraham Polonsky's blistering *Force of Evil* (1948) inhabits the offices of New York's financial district, its most memorable scene comes when John Garfield's character descends, step after step, to the base of the George Washington Bridge on the Hudson River. There, like some flotsam washed up on the bank, is the corpse of his brother. And a chilling voice-over line: 'It felt like I was going down to the bottom of the world...'

Even as the waterfront has shifted and transformed, its grim cinematic associations have persisted. Popeye Doyle's beat in *The French Connection* (Friedkin, 1971), for instance, is along the East River. And his ultimate confrontation with the drug baron Charnier is in a dank warehouse on Randall's Island, beneath the Triborough Bridge. Water all around, like a noose.

If you want it all distilled into less than a minute's worth of footage, then how about the closing scene of Martin Scorsese's *Gangs of New York* (2002)? It begins with a shot of a riverside cemetery, looking across into nineteenth century Manhattan from Brooklyn. Overlapping shots then tumble on one from another, a time-lapsed portrait of New York's developing skyline. The cemetery crumbles and sinks beneath the undergrowth, while New York's skyscrapers emerge from above the water. The final panorama includes the two towers of the World Trade Center, stood intact and imposing. Then, fade to black.

It says everything about New York's waterfront: death, life, tragedy, regeneration, growth and defiance. The beginning of many adventures, indeed. ✢

in 1954. Again, New York's jetties and piers are blighted by rot; in this case the pervasive influence of the mobs that control business in and around the New York and New Jersey harbour area. And although one man alone cannot beat them, Marlon Brando's beat-up longshoreman, Terry Malloy, certainly makes a decent attempt at it. 'Get me on my feet,' he bawls at the film's end, an ordinary man turned heroic.

There are plenty more ordinary, quietly heroic men along the waterfront, but the noir directors of the 1940s and '50s generally preferred to dwell on the freaks, sociopaths and hustlers. Sam Fuller's *Pickup on South Street* (1953) is a case in point. The lead character – Richard Widmark's shark-ish pickpocket, Skip McCoy – lives in a shack on stilts

Even as the waterfront has shifted and transformed, its grim cinematic associations have persisted.

NEW YORK LOCATIONS

SCENES 15-21

THE GODFATHER (1972)

LOCATION *128 Mott Street, Little Italy, Manhattan*

FRANCIS FORD COPPOLA reinvented the gangster genre with his masterpiece *The Godfather*, a 1972 film chronicling the syndicate of a New York mafia family headed by Vito Corleone (Marlon Brando). The story unfolds as his beloved son Michael returns from war a hero with no interest in joining the family business. However, after the Godfather declines a business proposition involving the selling of drugs, his rivals attempt a hit on him, which triggers a war and changes Michael's future. The pivotal point occurs as Vito strolls through Little Italy to buy oranges from a fruit stand. Coppola used oranges symbolically throughout *The Godfather Trilogy* to foreshadow bad things to come, and here is perhaps the most memorable example. After buying the fruit, Don Vito moves towards Fredo (John Cazale), who is waiting for him at the parked car. Suddenly, two men walk briskly towards the don. Upon seeing them he drops his paper bag and darts quickly towards the car. They catch up and shoot five bullets into his back. Fredo tries to retaliate but instead hysterically fumbles with the gun. His trembling hands cause it to fall amid the rolling fruit. The scene was shot in Little Italy, New York, using the exteriors of an old loft building at 128 Mott Street and, besides witnessing our main character getting gunned down within the first 45 minutes, what elevates the horror is seeing it take place in the Don's own territory. **•→ Wael Khairy**

Directed by Francis Ford Copolla
Scene description: Don Vito Corleone is shot in Little Italy
Timecode for scene: 1:45:21 – 1:47:05

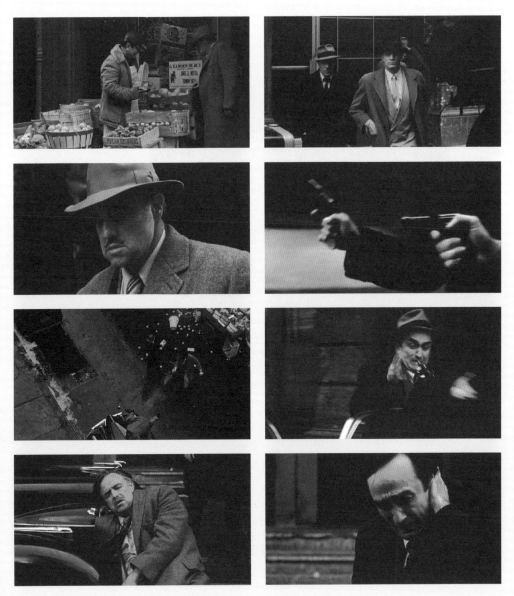

BLACK CAESAR (1973)

LOCATION *127th Street – Edgecombe Avenue, Harlem*

THE 1970S were the nadir of New York's history. And none of its neighborhoods were hit harder than Harlem. Once considered the capital of 'Black America', home of the Harlem Renaissance, it became a victim of neglect, typified by its derelict buildings, schools, and parks. But despite its downward spiral, those who remained continued to survive and thrive, emitting a vibrancy that would refuse to break down with its surroundings. It is important to remember this context when watching *Black Caesar*. Particularly in this sequence, in which the film's lead character, Tommy Gibbs (Fred Williamson), sets out to take over 127th Street to Edgecombe Avenue – a district considered to be 'a piece of shit' by the local Mafioso. The scenes showcase a Harlem that refuses to die: lined with dilapidated sidewalks and shops, yet bustling with life lived on the outside. Being a Blaxploitation film, *Black Caesar*'s limitations are evident in casting and style. But these do not hinder the immediacy and feel of the story's locale. Watch and see how surrounding crowds genuinely treat Tommy Gibbs (and the camera that films him) like a celebrity. Notice how unvarnished camera techniques give the scene an almost documentary-like authenticity. Look out for the outdoor Afro store display; for Fred Williamson, with his unshakably confident and sexy portrayal; and for James Brown's sensational soundtrack ('The Boss'). We may never again see Harlem at its lowest or as alive. **•• *Michael Mirasol***

Above Intersection at Edgecombe Ave & Bradhurst Ave at W 142 Street

Directed by Larry Cohen
Scene description: Walking the streets of Harlem
Timecode for scene: 0:14:12 – 0:15:00

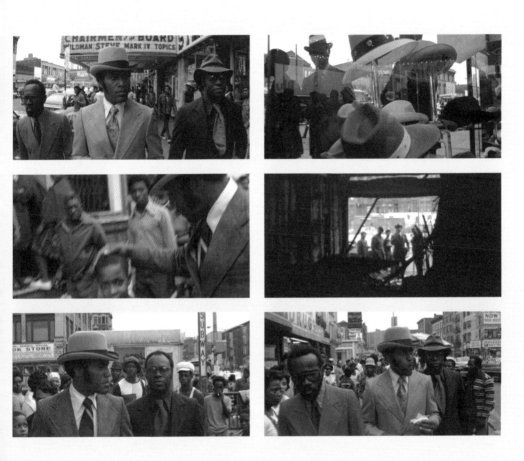

SERPICO (1973)

Hell Gate Bridge, Astoria, Queens

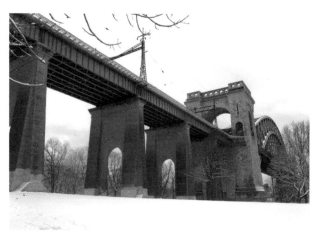

FRANK SERPICO (Al Pacino) is the counter-culture oddball of the NYPD. His ideals earn him the disdain and jokes of the force. But ridicule is a petty thing. It's the corruption Serpico can't ignore. Every precinct is loaded with shakedowns and payoffs. He refuses to participate, and constantly has his arm twisted by every cop he works with. He tries to report it, but his complaints vanish under platitudes and promises. In desperation, Serpico threatens to go to the press. He meets Captain Inspector McClain (Biff McGuire) under Hell Gate Bridge, presumably the safest location Serpico can think of. No ears. No eyes. Just grass, trees and the pillars of the bridge. It's one of the only expansive scenes in a claustrophobic movie. Throughout the film, Serpico is constantly filmed in dim hallways, tight streets and dark cars. It emphasizes the scrutiny on him and the increasing terror and pressure to conform. It's a delicious and ugly irony that when the line is inexorably drawn between Serpico and the NYPD it occurs in the one shot in which we can truly breathe. Perhaps that's the idea. Serpico knows his dangerous intentions are now out in the open. So do they. As he screams in anger, the camera pulls back, making him a tiny and pitiable figure on the ample landscape, and emphasizing his isolation. His pleas fall on the deaf ears of McClain and Hell Gate Bridge, and the film plunges back into narrow and sweaty gloom. ⇢*Elisabeth Rappe*

Directed by Sidney Lumet
Scene description: A confrontation under Hell Gate Bridge
Timecode for scene: 1:21:14 – 1:22:14

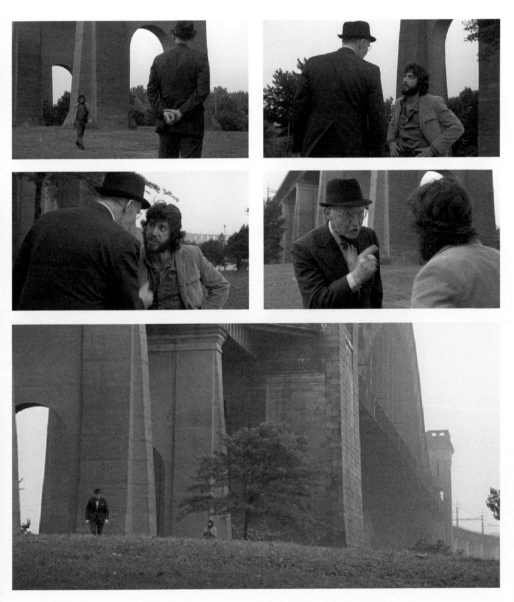

ALICE IN THE CITIES (1974)

William A. Shea Memorial Stadium (AKA Shea Stadium), Queens

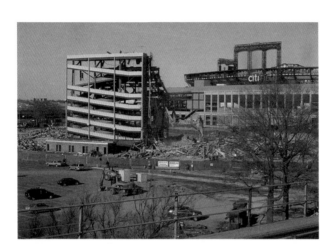

WE HEAR IT before we see it. 'Sounds like an organ,' says our protagonist, a travelling German journalist whose name is not yet known to us. 'That's... Shea Stadium,' he is told. We cut to the famous sports ground. A baseball game is in progress. The players, tiny and bright in their white uniforms against the grey grass are part of a team, but their smallness and their regimented distance from one another emphasizes each man's isolation. The camera pans towards the crowd. The spectators are busy and noisy, but the dark grey spaces between them – the empty seats – suggest the loneliness that comes in crowds. The camera continues, and we see the source of the music. The organist sits, alone, in her box, creating the stadium's atmosphere but unable to share in it. She could be at home, practising on a keyboard. The scene is over so quickly our visit to Shea seems shoehorned into the film. And this is the point. Such touristic visits to landmarks are almost always perfunctory; they give not an impression of a place, but a sense of distance from it. The scene is an exquisite expression of the isolation felt by the lead character as he travels. He compulsively snaps Polaroid pictures to record what he sees. Now, *Alice in the Cities* has a similar function: Shea Stadium, once one of the great landmarks in a city that sometimes seems composed only of great landmarks, was dismantled in February 2008. Here it is preserved. ◄► *Scott Jordan Harris*

Above Shea Stadium being demolished in 2009 (Photo © Erwin Bernal)

Directed by Wim Wenders
Scene description: Take me out to the ball game
Timecode for scene: 0:13:07 – 0:13:49

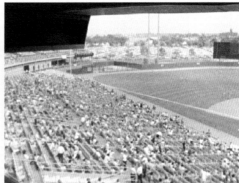

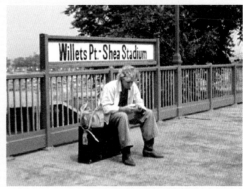

THE TAKING OF PELHAM 123 (1974)

Disused IND track near Court Street Station, Broadway, Manhattan

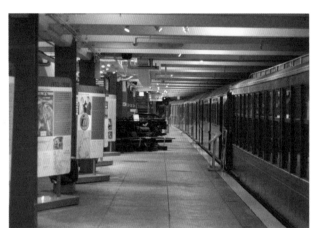

WHAT BETTER PLACE for a hijack than the New York subway? Joseph Sargent's nervy 1974 thriller sees an armed gang, led by Robert Shaw's cold mercenary Mr Blue, commandeer train Pelham 123, demanding $1 million for the release of seventeen hostages. Made at the zenith of New York's notoriety as a criminal hotspot, the film is a revealing portrait of a city under siege, the hostages self-consciously designed as a microcosm of New York society. Credited only by type (e.g. 'The Pimp', 'The Alcoholic', 'The Homosexual' and 'The Hippie'), they are united in the city's familiar world-weary sarcasm. Hence Mr Blue's initial announcement is laughed off, the carriage's occupants perhaps assuming it's a prank or performance art. 'Are those real guns?' a boy asks in awed disbelief. A woman asks in jest if she can leave for an urgent appointment. Only when a back-talking passenger is brutally beaten does the mood – and with it the carriage lights – darken. 'Hostages?' one asks. 'What did you think, guests?' another replies sardonically. The realism is enhanced by shooting on genuine – if disused – tracks on the IND Fulton Street Line, surrounding the decommissioned Court Street station in Brooklyn. (Although, at the mayor's request, the carriage used was un-blighted by graffiti). The location, now the city's Transit Museum, remains a popular movie location, and again held Pelham 123 to hostage in Tony Scott's 2009 re-make. Incidentally, the train is so named because it left Pelham Bay at 1:23pm – a combination which real-life Transit Authority dispatchers avoid replicating. **Simon Kinnear**

Above New York's Transit Museum (Photos © Marcin Wichary / © Jason Paris)

Directed by Joseph Sargent
Scene description: Armed hijackers reveal themselves to subway passengers
Timecode for scene: 0:17:48 – 0:22:25

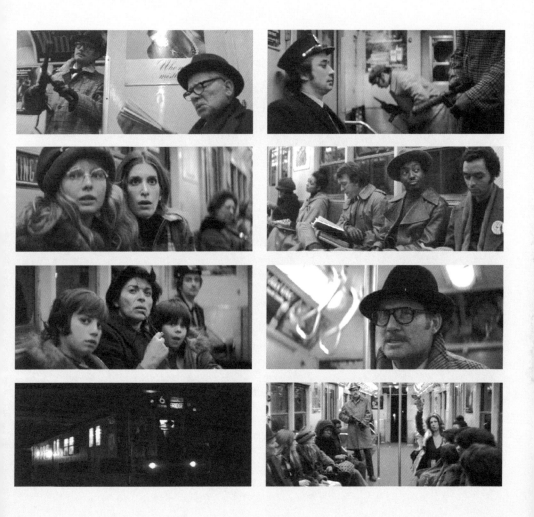

DOG DAY AFTERNOON (1975)

LOCATION *285 Prospect Park West between 17th and 18th streets, Brooklyn*

SIDNEY LUMET'S *Dog Day Afternoon* is based on an actual bank robbery that took place three years prior to the release of the film. Al Pacino plays bank robber Sonny Wortzik who, on 22 August, bursts into a Brooklyn bank for a run-of-the-mill robbery, only to end up surrounded by dozens of armed police officers. Hours after the failed heist, crowds gather around the bank. Once the media joins the circus it became the hottest event on live television. Sonny frequently leaves the shelter of the bank to negotiate and shout abuse at the gun-pointing cops. Meanwhile, Salvatore Naturile (John Cazale), his slow-witted accomplice, keeps an eye on the hostages. The most memorable stand-off in the film finds Sonny outside, rejecting an offer made by Detective Moretti (Charles Durning). Sonny then takes a rebellious step closer to the crowd and yells, 'Attica! Attica!' referring to the infamous 1971 prison riot during which the New York City police showered inmates with bullets. The crowd responds with a loud roar, making Sonny momentarily their hero. This powerful scene is the turning point of the picture; it marks a sudden shift in power from the cops to the robbers. *Dog Day Afternoon* is a quintessential New York film that explores the tensions between sexuality, crime, law and the media in the 1970s. It was shot on location at Prospect Park West between 17th and 18th Street, south of Park Slope, Brooklyn. •◦ ***Wael Khairy***

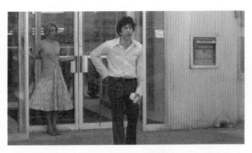
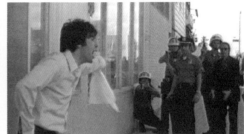
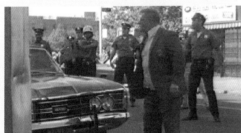
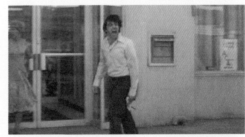
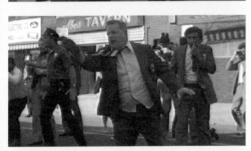

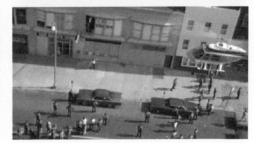

TAXI DRIVER (1976)

LOCATION *204–226 East 13th Street, between Second and Third Avenue, East Village, Manhattan*

AT THE HEART of Martin Scorsese's cathartic study of a New Yorker on the edge is a cruel joke at the city's expense – that only a psychologically damaged Vietnam veteran would be mad enough to visit its seamier neighbourhoods. And that's exactly what new cabbie Travis Bickle (Robert De Niro) promises, boasting, 'I'll work anytime, anywhere.' This isn't necessarily a good thing. Outraged at the moral squalor of a city where 'all the animals come out at night,' Travis determines to exact vengeance: a journey that leads to an urban underworld where underage prostitute Iris (Jodie Foster) is kept under armed guard by pimp Sport (Harvey Keitel). After shooting Sport in the street outside, Travis takes his orgiastic violence into the brothel, where, despite being repeatedly shot, he manages to kill Iris's abusers. The unvarnished brutality (cheeks are punctured, fingers blown off, walls splattered with blood) led US censors to order Scorsese to de-saturate the colours, but the weird effect this created only enhances the scene's chilling impact. Native New Yorker Scorsese located this modern-day Hell on East 13th Street, between Second and Third Avenue. Travis and Sport's confrontation takes place outside #204; after Travis pauses to psyche himself up on the steps of #208, he moves to the brothel exterior at #226. Its here – after Travis' bloody rampage – that the camera draws back to reveal a circus of police and passers-by, craning their necks for a better look. All the animals come out at night, indeed... to watch. ⚫*Simon Kinnear*

Directed by Martin Scorsese
Scene description: *Travis Bickle blasts his way into a brothel*
Timecode for scene: *1:34:07 – 1:41:42*

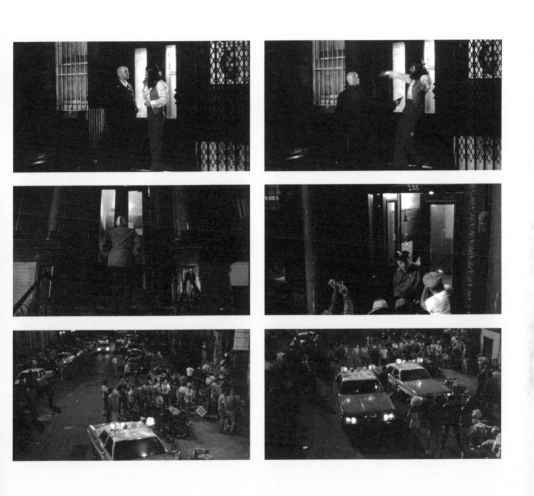

Images © 1976 Columbia Pictures Corporation; Bill/Phillips; Italo/Judeo Productions

MANHATTAN MAN

Woody Allen's Love Affair with New York

Text by
SCOTT
JORDAN
HARRIS

'Don't you see the rest of the country looks upon New York like we're left-wing, communist, Jewish, homosexual pornographers? I think of us that way sometimes and I live here.'
– Woody Allen, as Alvy Singer, in *Annie Hall* (1977)

THIS STATEMENT sums up so much of Woody Allen's work. It is witty, searching, self-obsessed, and preoccupied with politics, religion and sex. Above that, though, it is concerned with the business of being a New Yorker. Here, Alvy Singer, perhaps Allen's most infamously neurotic character, obsesses not simply over his self-image, but over New York's. For Singer, as for innumerable characters in Allen's oeuvre, his being and his being a New Yorker are inseparable: his home city is as important a part of his identity as his gender or Jewishness. Later

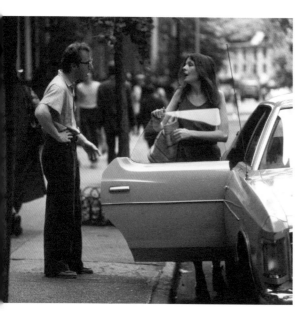

in the movie, when Singer is forced to travel to Los Angeles, he suffers paralysing nausea; it is as if the very air of another city is toxic for him. Like Isaac Davis, Allen's equivalent character in *Manhattan* (1979), Alvy 'can't function anywhere other than New York.'

Allen, unlike his two best known characters, can certainly function in cities other than New York – but, throughout his films, there is the sense he sees no real reason why he should. A Woody Allen character is as likely to feel all his needs are met by New York as he is to deliver a white-hot one-liner, pontificate about philosophy or have an extra-marital affair. Characters like Singer and Davis display only disdain for – or utter incomprehension of – fellow New Yorkers who desire to move away from the city, even if only for a brief holiday, and Allen often visually reinforces their judgement.

For instance, in *Manhattan* – in which Allen and his invaluable cinematographer, Gordon Willis, make New York look as exquisite as any city has ever been on-screen – the stunning monochrome cityscapes emphasise not only the smallness, but also the small-mindedness, of some of the characters. Here, Allen says without saying a thing, are people so self-involved they scarcely notice they are living in the world's most remarkable metropolis.

Allen's most unrestrained declarations of devotion to New York are not, though, found in the famous *Annie Hall* or *Manhattan*, but in a later, smaller and quieter picture: 1987's *Radio Days*. Allen appears only as the unseen narrator, but the film is nevertheless his most autobiographical. Many of the situations and locations shown are those of Allen's childhood – and those episodes that aren't factual recreations of periods in his life are at least truthful ones.

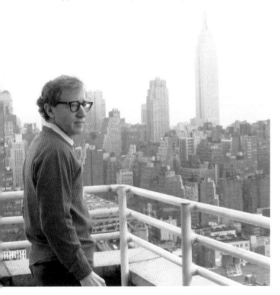

watching a sports team playing away from home. Allen's work has represented New York to the rest of the United States (and of the world) so repeatedly and so powerfully that, in the American imagination, he has become an icon of the city.

There is one piece of Woody Allen trivia that even those who detest his persona, and avoid his work, can be relied upon to know: despite his numerous nominations and several wins, Allen does not attend the Oscars. Instead – at least as the legend has it – he stays in New York, his first love, and plays jazz, his second. But at the 74th Academy Awards, the first since the terrorist attacks of September 11 2001, Allen at last accepted an invitation from the Academy.

He was asked to introduce a short film about New York in the movies, and his appearance prompted a standing ovation. He didn't need to give a long and inspiring speech (indeed, he didn't do much more than tell a few jokes): his presence was enough. The Academy wanted to celebrate and support New York City and by applauding Allen they were applauding its embodiment.

Such a description of Allen, though, doesn't fit the image of him, and of New York, projected by his work. For Allen, and the characters he creates, it seems unlikely there could be anyone who could embody the enormous, nourishing but unforgiving environment in which they live. Just as his characters are inconsequential specks within an astonishing but uncaring universe, so too are they individually insignificant citizens of a harsh and beautiful city that dwarfs them. But, while they may feel hostility towards the universe, they rarely feel anything short of love for New York.

Having begun with a quote from one of Allen's great late-1970s classics, perhaps we should end with one too. Allen is often accused of doing nothing more as an actor than playing himself and, in general, this is an unsustainably reductive reading. Seldom, though, has Allen been himself on-screen more than in the opening moments of *Manhattan*, when his character, who is beginning a book about a character based upon himself, declares, 'Chapter One. He adored New York. He idolized it out of all proportion...' ✦

Seth Green plays Joe, a boy who is more obviously, and more fully, Allen's alter ego than any of the characters Allen has ever written for himself to play. When Joe visits Radio City Music Hall, he is overwhelmed with wonderment. He says it is – or rather, it was – the most beautiful place he has ever seen; a visit to an Automat produces a similar sensation. *Radio Days* is ostensibly about Allen's love of the US radio programmes of the 1930s and '40s – but the true object of its affections is the city in which he listened to them. Cinema has heard many hymns to New York, but in none is the music as moving, or the sentiments as earnest, as in Allen's.

Indeed, Allen is so linked with New York in the mind of the moviegoer that watching those films of his not shot in the city – like the early *Take the Money and Run* (1969) and *Play It Again, Sam* (Ross, 1972), which were made in San Francisco, or the later European-set films, such as *Match Point* (2005) and *Vicky Cristina Barcelona* (2008) – feels often like

Allen, unlike his two best known characters, can certainly function in cities other than New York – but, throughout his films, there is the sense he sees no real reason why he should.

LOCATIONS MAP

NEW YORK

*Map used for guidance
and reference only*

The Bronx

Manhattan

27

24

26

28

Queens

Brooklyn

23

22

25

NEW YORK LOCATIONS

SCENES
22-28

ANNIE HALL (1977)

LOCATION

The Thunderbolt rollercoaster, over The Kensington Hotel, Coney Island, Brooklyn

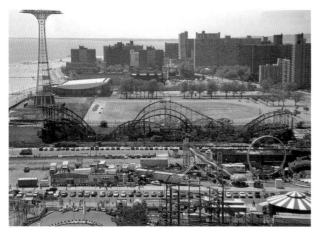

IT'S ONE OF the funniest flashbacks in film: Woody Allen's Alvy Singer exclaims, 'My analyst says I exaggerate my childhood memories – but I swear I was brought up underneath the rollercoaster in the Coney Island section of Brooklyn.' We see a boxy wooden house nestled improbably beneath the hulking track of a rollercoaster. The rollercoaster's carriages approach. Unperturbed, Alvy's mother leans out of a window to clean, while inside his father sits reading a newspaper. Young Alvy braces himself against a wobbling table. Overhead the rollercoaster rumbles, shaking the soup from his spoon. 'Maybe that accounts for my personality,' says Allen. 'Which is a little nervous I think.' Many who watch *Annie Hall* think the house under the rollercoaster is literally a comic construction. It is not. It is Coney Island's Kensington Hotel, which was built in 1895; the rollercoaster is The Thunderbolt, which was erected around it in 1926. Both stood until 2000 – when they were controversially demolished – and, for 40 years, the hotel was occupied by Mae Timpano and her partner, Fred Moran, who owned and operated The Thunderbolt. (Mae maintained the rollercoaster did rock the house with every ride, but not as much as Allen makes out.) The scene was not in the film's original script: Allen included it after he spotted the unique landmark while scouting locations. Seldom can a city location have been blended so effectively into a film: whenever lists of cinema's finest cameo appearances are made, the Kensington Hotel's should be in contention. **Scott Jordan Harris**

Above The Thunderbolt photographed in 1996 (Photos © Joe Schwartz)

Directed by Woody Allen
Scene description: The house under the rollercoaster
Timecode for scene: 0:03:12 – 0:03:42

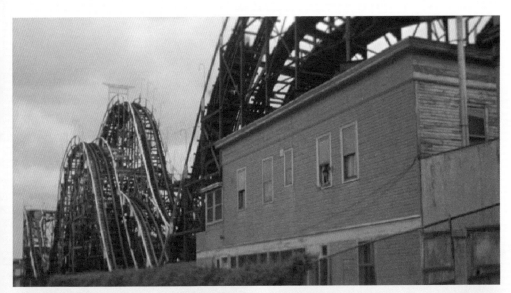

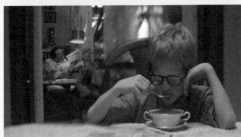

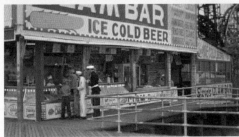

SATURDAY NIGHT FEVER (1977)

LOCATION *86th Street, Brooklyn*

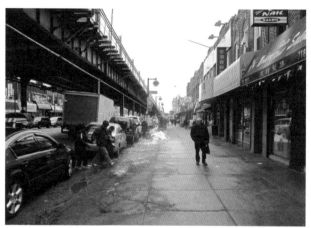

THE CAMERA pulls out above the Brooklyn Bridge, looking at a receding Manhattan skyline, taking us down towards the apartment blocks and blaring subway trains of Brooklyn where our strutting prince lives a fantasy life. Appropriately for this fairy tale, as the music of 'Night Fever' pounds, we first glimpse our prince by his flamboyant red shoes, like Hans Christian Anderson's with a life of their own. Revealed as a strutting Adonis, Tony's (John Travolta) saunter along 86th Street, Brooklyn, reveals his double life as a disco king and blue-collar lady killer checking out the babes, oblivious to the adoration of the pizza waitress at 1969 86th Street, Bensonhurst, while he stuffs his face; the Steadicam now angles him dramatically looking up from the pavement, changing from left to right of him, he is huge against that blue sky. Like an Olympian God striding. Is that how he sees himself? But we see he's really a hardware assistant, as he swings his paint can. Distracted by a blue shirt for his next Saturday night and a worthy conquest, Tony suddenly realises that he must return to his mundane quest. Tony, the prince, the demigod, rushes back to 7305 Fifth Avenue, Bay Ridge, Brooklyn, and will get his shop coat on before sweet talking his angry customer with a flash of that lady killer smile to buy the can for three dollars more than he paid for it.
•◦Samira Ahmed

Above 86th Street, Brooklyn / Lenny's Pizza

Directed by John Badham
Scene description: Tony Manero walks the walk
Timecode for scene: 0:00:13 – 0:04:10

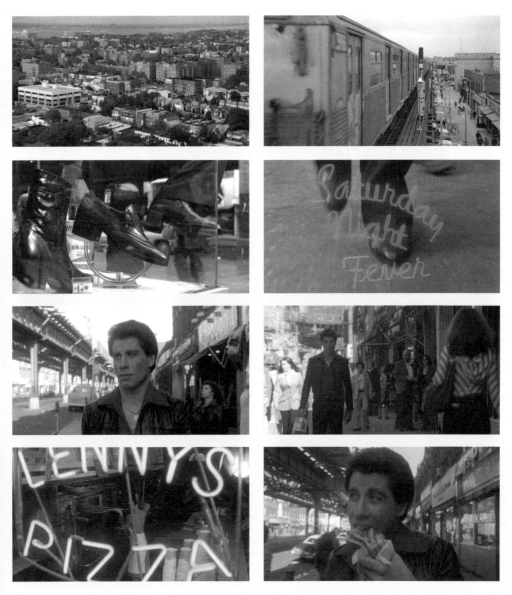

MANHATTAN (1979)

LOCATION

A bench at the end of East 58th Street by East River Drive, Manhattan

MORE THAN A FILM, a mere ode, Woody Allen's *Manhattan* is a distillation of New York as he knows it: alluring, quixotic, dramatic, brimming with gatherings of over-educated people, their interests and their various opinions about those interests. Isaac and Mary are two such people. They first meet in the presence of their respective partners, and sealed their first impressions in a verbal spar. The battle of wits continues through a second encounter, but sparks brighten as they walk and bicker down a Manhattan street after a splashy affair at the Museum of Modern Art. 'Sometimes you have a losing personality,' he tells her. 'I say what's on my mind and if you can't take it, then fuck off,' she replies. But on they talk, and in one of the most atmospheric and romantic sequences ever shot, they stroll across the velvety Manhattan night, ending up on a bench facing the East River as the Queensboro Bridge stands majestically by, gesturing at the dark sky, which holds a sea of city lights, each harbouring a New York story of its own. That iconic shot, drenched sumptuously in black-and-white, framed against an unforgettable skyline, confirmed not only *Manhattan* the film as one of Allen's greatest, but Manhattan the place as an indelible mark in one of the greatest cities on earth.
➻ *Grace Wang*

Directed by Woody Allen
Scene description: Isaac and Mary sit on a bench besides Queensboro Bridge
Timecode for scene: 0:27:15 – 0:28:12

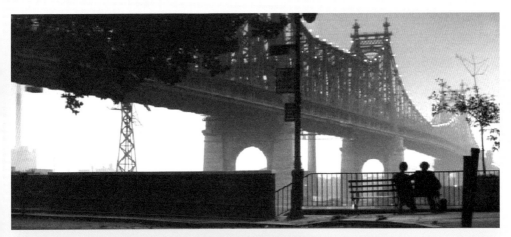

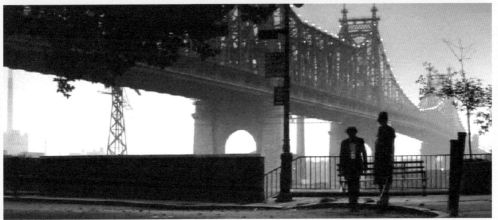

THE WARRIORS (1979)

LOCATION *Coney Island, Brooklyn*

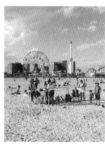

'THIS IS WHAT we fought all night to get back to,' laments Swan (Michael Beck), the second-in-command of street gang The Warriors, upon returning home to Coney Island after a turbulent journey that has entailed violent confrontations with such rivals as The Turnbull ACs, The Baseball Furies and The Punks. Walter Hill intended *The Warriors* to begin with a title card that would read, 'Sometime in the future,' but although that idea was rejected by Paramount, the final sequence at Coney Island certainly has a post-apocalyptic quality. Arriving at the Stillwell Avenue subway station after sunrise, The Warriors and tough-talking Bronx beauty, Mercy (Deborah Van Valkenburgh), wander through a fairground that is as dilapidated as it is deserted, en route to the rubbish-strewn beach. It is there that they encounter The Rogues, whose leader, Luther (David Patrick Kelly), has caused all the trouble by framing the Warriors for the shooting of Cyrus, the leader of The Gramercy Riffs. 'When we see the ocean, we figure we're home, we're safe,' muses Swan. 'This time you got it wrong,' insists Luther. However, the intervention of the Gramercy Riffs, who have realised that The Warriors were not responsible for their leader's murder, ensures that gang justice is enforced. The washed-out wasteland of the supposedly triumphant final frames – the surviving members walk along the shore to the accompaniment of Joe Walsh's upbeat 'In the City' – echoes Swan's earlier statement by suggesting the futility in fighting for such an unremarkable piece of turf. **⦚ John Berra**

(Photos © William Frasca)

Directed by Walter Hill
Scene description: The Warriors return to Coney Island
Timecode for scene: 1:17:14 – 1:25:32

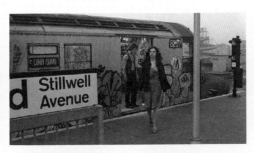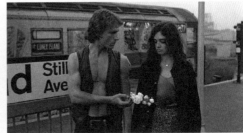

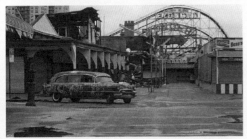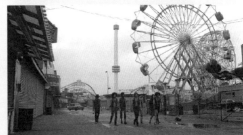

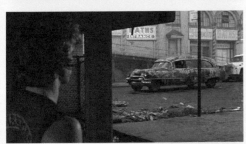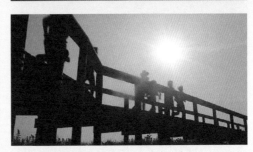

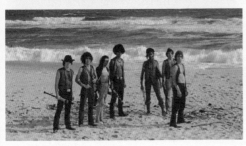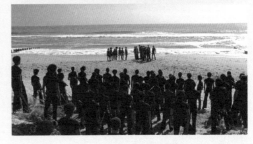

Images © 1979 Paramount Pictures

BROADWAY DANNY ROSE (1984)

LOCATION *Carnegie Deli, 854 Seventh Avenue, Manhattan*

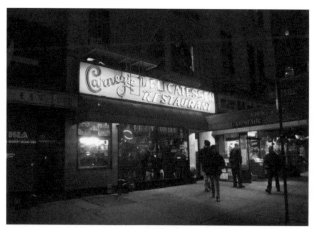

BROADWAY DANNY ROSE is bookended by scenes set at Milton Parker and Leo Steiner's world famous Carnegie Deli, founded in 1937 and found next to Carnegie Hall at 55th Street and Seventh Avenue. The deli, renowned for its gargantuan sandwiches, came to be the favoured hangout for the likes of Milton Berle, Jackie Mason, Henny Youngman and many other post-war 'Borscht Belt' comedians. So it is fitting for the film to open on a night shot of the deli's neon-lit storefront and cut inside to a slow, warm tracking shot towards a table occupied by a couple of old comics chewing the fat. Over a series of smooth, folding dissolves the group swells to seven and the showbiz stories start to flow, with the character and assorted exploits of erstwhile impresario Danny Rose (Allen) eventually forming the focus for the anecdotes. That same illuminated storefront is also the last shot of the film, when we see Danny make up with mob moll Tina (Mia Farrow). It is over this shot that we learn the restaurant has given Danny 'the single greatest honour you can get in the Broadway area.' There he is, on the menu: The Danny Rose Special – cream cheese on a bagel with marinara sauce. In a case of life imitating art, and as a nod to the free advertising that the film provided, the deli did christen a sandwich after the character, although the real thing is a mountainous pastrami and corned beef combo. ↦ *Jez Conolly*

Directed by Woody Allen
Scene description: Opening scene entering the Carnegie Deli
Timecode for scene: 1:12:34 – 1:15:12

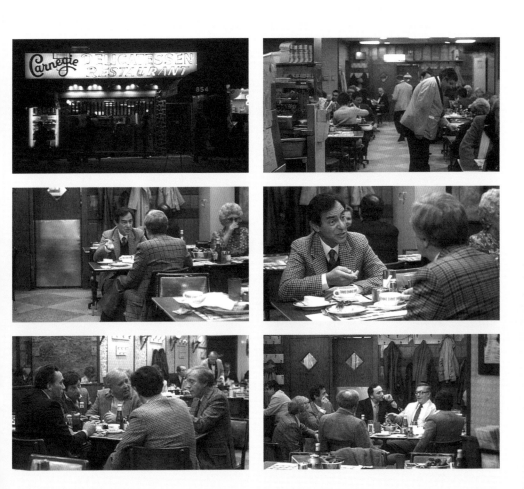

GHOSTBUSTERS (1984)

LOCATION

The Shandor Building, 55 Central Park West, Manhattan

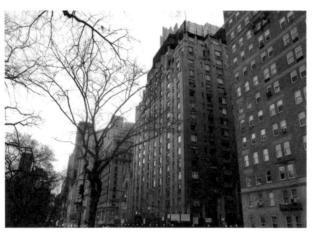

THE CLIMAX of Ivan Reitman's comedy blockbuster *Ghostbusters* takes place on the roof of the Shandor Building at Central Park West, where paranormal exterminators Peter Venkman (Bill Murray), Raymond Stantz (Dan Aykroyd), Egon Spengler (Harold Ramis) and Winston Zeddemore (Ernie Hudson) must prevent one of the most exclusive areas of New York from being destroyed by a 100ft-tall Marshmallow Man that has been created by Raymond's nostalgic imagination. Although the Ghostbusters seem to have defeated the evil god Gozer with their trusty proton packs, Gozer's retreating voice states that a 'destructor' will follow, with its physical form being decided by the associated mental image of one of the team. 'I tried to think of the most harmless thing. Something I loved from my childhood: something that could never, ever possibly destroy us,' explains Raymond, temporarily traumatised by this monstrous manifestation of a beloved childhood memory. Venkman's proposed solution – 'He's a sailor; he's in New York. We get this guy laid, we won't have any trouble' – is typically flippant, but not particularly practical. The more scientifically capable Egon may be 'terrified beyond the capacity for rational thought' but still has the 'radical idea' of 'crossing the streams' of their proton packs in order to destroy Gozer's dimensional portal, thereby causing Stay Puft to explode into messy – yet harmless – pieces of marshmallow that cover the streets below. Sarcasm and spectacle combine in crowd-pleasing fashion as the Ghostbusters scramble to save a city block that is far beyond their rental budget. **John Berra**

Directed by Ivan Reitman
Scene description: The Stay Puft marshmallow man takes Central Park West
Timecode for scene: 1:27:26 – 1:31:06

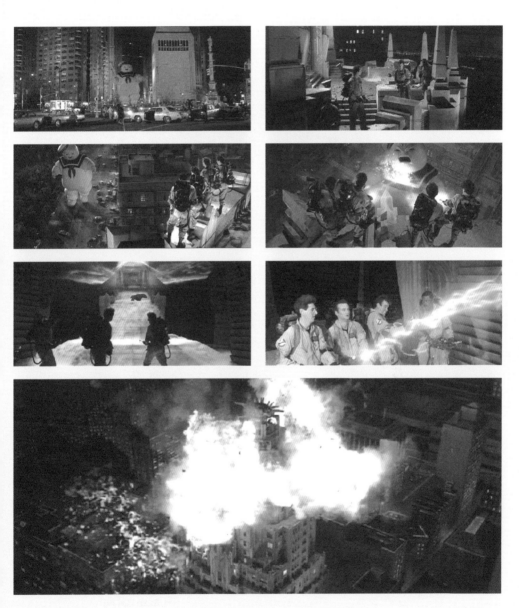

SID AND NANCY (1986)

LOCATION *Chelsea Hotel, 222 West 23rd Street, Chelsea, Manhattan*

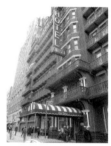

MANHATTAN'S CHELSEA HOTEL, a designated New York City landmark, is as intrinsic to the history of the city as it is to that of popular culture. Opened in 1884, the Chelsea has a long and rich tradition of notable guests and long-term residents drawn from the worlds of art, literature, music and film, including Stanley Kubrick, Janis Joplin, Charles Bukowski and the ill-fated lovers Sid Vicious and Nancy Spungen, described by Roger Ebert as 'Punk Rock's Romeo and Juliet'. In Alex Cox's portrait of the doomed Sex Pistol Vicious (Gary Oldman), and his mutually destructive, drug-addled relationship with Spungen (Chloe Webb), the Chelsea is used to give an authentic edge to the recreation of the pair's now-infamous demise. The stark opening sequence, with Spungen dead and a mute Vicious being arrested in their hotel room, sets the morbid tone for the film's non-linear narrative, while making great use of the Chelsea's shabby grandeur and iconic status. As Spungen's lifeless form is taken away in a body bag, Vicious is led through the hotel's corridors by the two arresting officers, down into the busy lobby and out into the street, straight into the throng of reporters and photographers waiting outside. The hotel's imposing architectural facade, with the street number 222 emblazoned on the entrance's awning, is instantly recognisable, strengthening the impact of the cultural history being revisited. Cox's biopic expertly uses this most evocative of locations to establish time, place and narrative theme. **⊷Neil Mitchell**

Directed by Alex Cox
Scene description: Anarchy in the Chelsea Hotel
Timecode for scene: 0:00:10 – 0:02:37

CINEMA 16

New York and the Birth of Beat

Text by
PETER
HOSKIN

1959: THE YEAR, as the title of a book by Fred Kaplan puts it, when everything changed. It was the year when Miles Davis burned his *Kind of Blue* onto vinyl. The year when William Burroughs sprayed *Naked Lunch* from his typewriter. The year of the pill and the microchip, of the New Wave and the *Twilight Zone*. And, in New York, it was the year when a new type of American cinema developed and caught hold. Call it what you will: independent cinema, the underground, improvisatory film, whatever. But don't forget: 1959 was the year.

The story begins with Amos Vogel, whose Austrian parents had, like so many others, fled to America when their country was subsumed by Nazi Germany in 1938. Nine years later, and Vogel had established a film society in New York City. Its name: Cinema 16. Its purpose: to show films, as Vogel wrote, 'that comment on the state of man, his world and his crisis, either by means of realistic documentation or through experimental techniques [...]

it finds excitement in the life of ants, Hindustan music, microbiology, aboriginal life.' Like all such groups, Cinema 16 started small – a handful of screenings in Greenwich Village's Provincetown Playhouse. But, by the late Fifties, it was comfortably packing out the 1,600-seat Central Needle Trades Auditorium (later the Fashion Industries Auditorium) on West 24th Street. Brando, Mailer and Sontag were among its audience members.

Did John Cassavetes ever visit Cinema 16 in its early years? It is hard to believe that he would have missed it. After all, this young actor from Long Island was seeking out exactly the sort of cinema that Vogel placed a premium on: human, realistic, restlessly experimental. In an article for *Film Culture* magazine in 1958, Cassavetes began: 'Hollywood is not failing. It has failed' – and only grew more agitated from there. His specific concern was that the American film industry had become too exclusive and self-serving. So he decided to take it on in the best way could think. He decided to make his own feature.

No need to dwell on the history of Cassavetes's *Shadows* (1959) here; suffice to say that there is still controversy over the different cuts of the film – which version is more radical, which is truer, that kind of thing. But the fundamental point remains: that, from its Charles Mingus score to its final title card, *Shadows* is a creature of spontaneity. Gone are the complicated set-ups and deliveries of 'Product Hollywood', to be replaced with footage shot hastily, and cheaply, in and around Times Square. And gone, too, is deliberate melodrama, to be replaced with a haphazard focus on the lives of three African American siblings. 'The film you have just seen was an improvisation,' it declares at the end. At the very least, it certainly feels like one.

Shadows sounded as though it might satisfy,

and perhaps even exceed, the selection criteria for Cinema 16 – and, upon being shown a print of the film by Cassavetes, Vogel was sure of it. This was, in many respects, a kinetic, new way of doing cinema, but one which needed a midwife to pull it wailing onto the cultural landscape. So, Vogel duly handed over the $250 rental fee, and set about arranging a screening.

But that was, quite literally, only the half of it. Elsewhere in New York, the Beats were dabbling in celluloid – and with typically energetic results. The photographer Robert Frank and the painter Alfred Leslie had just directed a short film, *Pull My Daisy* (1959), based on the third act of an unpublished Jack Kerouac play. Its Beat pedigree was unimpeachable: Allen Ginsberg and his fellow poets, Gregory Corso and Peter Orlovsky, revel in bawdy acting roles,

Did John Cassavetes ever visit Cinema 16 in its early years? It is hard to believe that he would have missed it.

while Kerouac himself provides the voice-over narration. And so, too, was its iconoclastic spirit: 'there's nothing out there but a million screaming 90-year-old men being run over by gasoline trucks,' narrates Kerouac. 'So throw the match on it.'

The handheld asymmetry of *Pull My Daisy* mirrors that of *Shadows*, as does its bop impulsiveness. Take, for instance, the antics of Ginsberg (reinventing Harold Lloyd as a sociopath), which were so unpredictable that his co-conspirators doubted the film would ever be completed. Or Kerouac's own contribution, which – rather than following the script – was so full of inversions, syncopations and diversions that the composer David Amram related it to the 'challenges of Charlie Parker, soloing with his string orchestra at Birdland. [Kerouac's] words were like a jazz solo, soaring above and weaving through the structure of the film.' Vogel, for his part, was hooked.

And so we arrive at the night of 11 November 1959, and the twin premiere of *Pull My Daisy* and *Shadows* at Cinema 16. The audience was crammed with the noted and notorious of the New York art scene: Ginsberg, Kenneth Tynan, Paddy Chayevsky, and more. As Vogel put it, 'There was a lot of electricity in the air,' an electricity that flickered, occasionally, into 'outright booing and hissing,' and which burst, eventually, into a 'long and pronounced ovation.' In the aftermath of the screening, journals, magazines and newspapers hummed with discussion of the event, and *Shadows* was soon winning awards and being picked up for distribution deals. New York had shown that it could be done differently.

Although lineages can be deceptive, it is striking how many other independent-minded film-makers emerged in the contrails of that night at Cinema 16. *Village Voice* critic Jonas Mekas would produce his *Guns of the Trees* (1961), which featured poetic interludes from Ginsberg again. Ron Rice, Jack Smith and Kenneth Anger would make Beat-inflected films such as *The Flower Thief* (Rice, 1960), *Flaming Creatures* (Smith, 1963) and *Scorpio Rising* (Anger, 1964). Ten years later, the studios seemed to wake up to the new movement and the untapped potential of a counter-cultural market. The result was *Easy Rider* (Hopper, 1969) – and that, as they say, was that. ✣

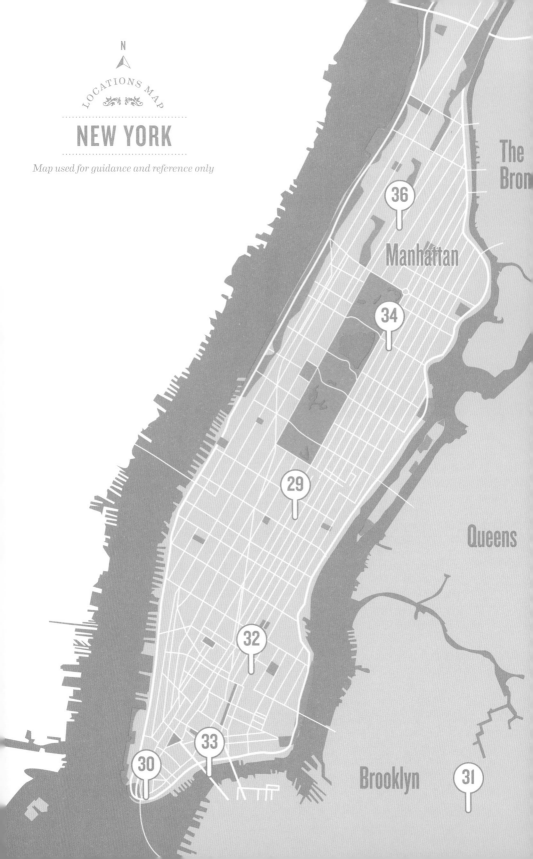

NEW YORK LOCATIONS

SCENES 29-36

WALL STREET (1987)

LOCATION *Grand Ballroom of the Roosevelt Hotel, 45 East 45th Street at Madison Avenue, Manhattan*

'**THE POINT IS,** ladies and gentleman, that greed, for lack of a better word, is good. Greed is right. Greed works.' Taking the stage at the annual meeting of the shareholders of Teldar Paper – an under-performing company he has been trying to wrestle control of for the past two years – charismatic corporate raider Gordon Gekko (Michael Douglas) outlines a business philosophy he believes, 'will not only save Teldar Paper, but that other malfunctioning corporation called the USA.' *Wall Street* is often cited as the quintessential portrait of 1980s greed, and Oliver Stone's fast-moving depiction of stock market machinations casts New York as an economic centre where 'money never sleeps'. As with much of the film, Gekko's speech at the Roosevelt Hotel is shot with a roving camera, capturing the shark-like mentality of the sector, as the raider works the room while dressed in his trademark high-roller attire. Bypassing the pleasantries associated with such addresses, Gekko blames the $110 million loss of the previous year on the complacency of overpaid executives, ridiculing the 33 Vice Presidents on the grounds that he has 'spent the last two months analysing what all these guys do, and I still can't figure it out.' The ever-persuasive Gekko is in his element, turning an initially hostile reception into a standing ovation as he refutes accusations of asset stripping and convinces the crowd he is actually a 'liberator' of companies, while corruptible protégé Bud Fox (Charlie Sheen) watches in awe. ↔*John Berra*

Directed by Oliver Stone
Scene description: 'Greed, for lack of a better word, is good'
Timecode for scene: 1:14:41 – 1:18:53

WORKING GIRL (1988)

LOCATION *Statue of Liberty, Liberty Island, New York Harbor, Staten Island Ferry*

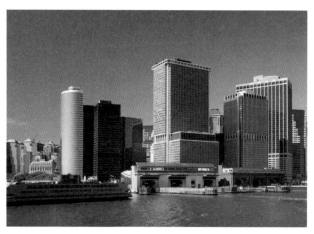

THE VERY FIRST SHOT of Mike Nichols's film, all two minutes of it, is an unbroken, dizzying, spiralling helicopter ride around the head of the Statue of Liberty. We meet Frédéric Bartholdi's green lady, that totem of American freedom, close up and face on in the first few moments as she gazes stoically out across the city's harbour. From that starting point, we are taken on a slingshot spin around her, taking in the familiar Manhattan skyline, and catching up with the Staten Island Ferry as it moves towards the twin towers of the World Trade Center. A travelling dissolve takes us on board the ferry and past row upon row of city workers, sipping coffee in the city that never sleeps and leafing through their morning newspapers. We come to rest finally on stock broker's secretary Tess McGill (Melanie Griffiths) as she is indulging in a small birthday celebration with her friend Cynthia (Joan Cusack). Cynthia gives Tess a cupcake pricked with three lit birthday candles, an echo perhaps of the statue's crown and, for Tess, a little taste of liberty. As the ferry docks and disgorges its cargo of suited and stressed employees, Tess and Cynthia manage to stand out in the crowd, their big 1980s hairdos giving them several inches' advantage over those around them. By any standards these girls mean business. ❖*Jez Conolly*

Above Whitehall Street Staten Island Ferry Terminal (Photo above left © Daniel Schwen)

Directed by Mike Nichols
Scene description: Moving Upstate
Timecode for scene: 0:00:15 – 0:03:41

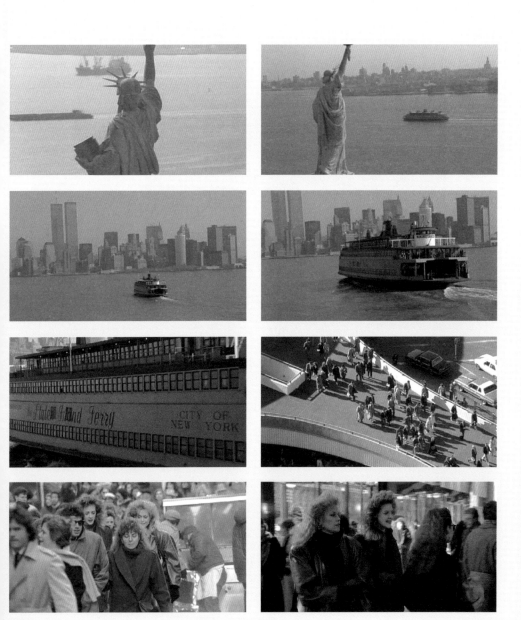

DO THE RIGHT THING (1989)

LOCATION *Stuyvesant Avenue, Brooklyn*

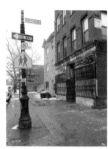

UP TO THE FILM'S shocking climax, Spike Lee's *Do the Right Thing* plays like a documentary on everyday life in the Bedford Stuyvesant neighborhood of Brooklyn. We get to know the inhabitants through their interactions on a single hot summer day. Lee uses carefully picked out music, dialogue, and artistic scenes full of energy to connect the micro storylines of individuals within the plot. When everything finally merges leading to the controversial and explosive riot scene, the viewer finally realises the grand message. Lee structures the plot by demonstrating how an insignificant conflict can develop into an all-out riot. It all starts with a customer boycotting an Italian pizzeria for not including African Americans on the restaurant's wall of fame. When he meets up with another angry customer who walks around with a loud stereo they decide to face Sal, the owner. The volume is amplified, a baseball bat is smashed against the stereo, and soon a fight breaks out. When the police arrive and brutally murder a young black man, the gathered crowd erupts in a frenzy of rage. One of Sal's employees directs the fury away from him by shattering the pizzeria window with a garbage bin. Mob mentality leads the crowd towards an Asian American trying to fend off people from his supermarket. *Do the Right Thing* is about how clashes exist where there is culture diversity. Without taking any sides, Lee objectively puts the viewer on location; in this case it's Stuyvesant Avenue. **↝ Wael Khairy**

Directed by Spike Lee
Scene description: The riot at Sal's Famous Pizzeria
Timecode for scene: 1:26:00 – 1:40:20

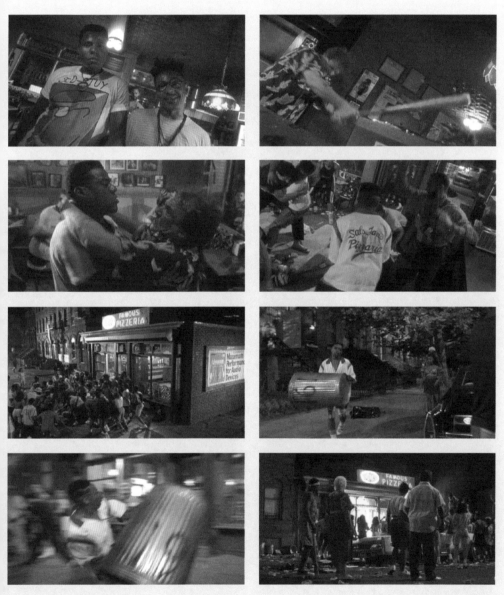

WHEN HARRY MET SALLY (1989)

LOCATION *Katz's Deli, 205 East Houston Street, Manhattan*

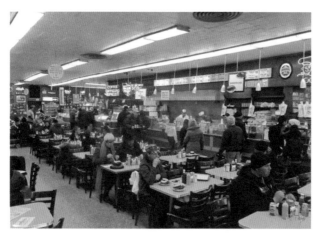
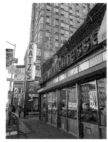

IT'S ONE OF the most famous scenes in American movies. As she fussily assembles a sandwich, Meg Ryan's Sally quizzes Billy Crystal's soft-hearted but chauvinistic Harry about the way he abandons the women with whom he has one night stands. He doesn't think the ladies mind his behaviour: he knows none of them has ever faked an orgasm. Sally is sceptical: 'All men are sure it never happened to them and most women... have done it. So you do the math.' Harry is still isn't swayed, and so Sally, transfixing everyone in the diner – and, indeed, everyone in every cinema in which the film has ever played – fakes a noisy climax. As much as this is Ryan's moment, it is Estelle Reiner, the director's more than middle-aged mother, who delivers the killer line: telling a waiter, 'I'll have what she's having.' The setting makes the scene. The crowded but orderly interior of Katz's Delicatessen is ideal: the closeness of the seating makes both the intimacy of the conversation, and the room-wide silence that meets the mock orgasm, believable, and the choice of restaurant immediately marks the scene as pure New York. Katz's – with its take-a-ticket billing system, 'Send a Salami to Your Boy in the Army' slogan, and delicious, hand-sliced, pastrami – is the best known deli in the city, which is to say it is the best known deli in the world. And, since 1989, the best known of its tables has been the one where Harry met Sally. **→Scott Jordan Harris**

Directed by Rob Reiner
Scene description: 'I'll have what she's having.'
Timecode for scene: 0:42:45 – 0:45:30

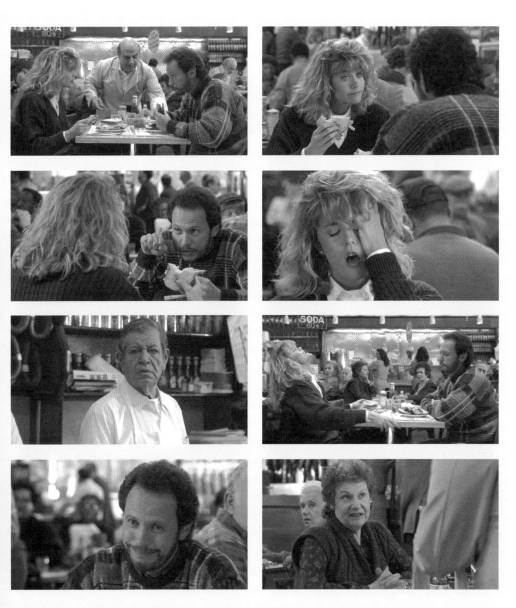

MO' BETTER BLUES (1990)

IT IS NIGHT. The scintillating New York City skyline presides. Lights shimmer in the East River. The camera pans left to the Brooklyn Bridge, and then cranes down. Alone on the bridge's elevated walkway stands jazz musician Bleek Gilliam (Denzel Washington), playing trumpet. The music we hear is 'Sing Soweto', by the legendary jazz artist/composer, Terence Blanchard. This scene is the most beautiful, sad and soulful in Spike Lee's 1990 film *Mo' Better Blues*, personifying the City That Never Sleeps. During this interlude we never see Mr. Washington's eyes. He blends into his dark caramel overcoat, oblivious to the traffic moving beneath him as he plays. His character, Bleek Gilliam, is focused. At this moment he and the music are one. The Brooklyn Bridge is one of New York City's greatest landmarks. The historic bridge has a recurring role in Mr. Lee's film. During this wonderful 70-second time-out, Mr. Washington's playing of 'Sing Soweto' is no accident. It's a tune saluting the South African city and its citizens' decades-long fight against apartheid in a land two continents away. In an unconscious way in Mo' Better Blues, the music and the span of the Brooklyn Bridge symbolically unites two continents: Africa and the Americas. The bridge appears again at night in the film about 15 minutes later, with 'Sing Soweto' reprised. This time, the lights on that hallowed bridge shine brighter than ever. **⟶Omar P.L. Moore**

Directed by Spike Lee
Scene description: A little night music
Timecode for scene: 1:30:46 – 1.31:56

Images © 1990 Univeral Pictures; 40 Acres & A Mule Filmworks

THE FISHER KING (1991)

Hunter College High School, 71 East 94th Street, Manhattan

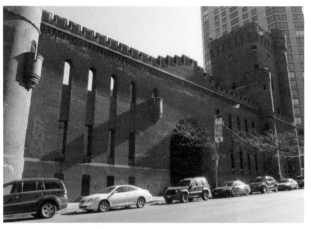

IT IS ARGUABLY the 'ballroom' scene set at Grand Central Station that people remember most vividly from *The Fisher King*; but Terry Gilliam made the appropriately incongruous red brick battlements of the Hunter College High School on the Upper East Side of Manhattan the beating heart of his film. The latter-day redbrick castellations of the building, formerly a nineteenth century regimental armoury, provide the perfect mock-Camelot backdrop to a key scene in the delusional search Parry (Robin Williams) makes for the Holy Grail. Disgraced shock-jock Jack Lucas (Jeff Bridges) has unwittingly opened a door on the homeless Parry's past, which initiates a fit of contorted screaming by the steps of the cod-Arthurian pile. It is here that, to Parry's eyes at least, a terrible vision emerges: a red knight on horseback erupting onto the streets of New York amid smoke and flames. Parry proceeds to chase this infernal illusion through Central Park, much to Lucas' bemusement. The bricks and mortar of the 'castle' – actually the home of a rich architect – have, through Parry's trauma-inspired hallucinations, come to form part of the furniture of his fantastical quest. And it is these same ramparts that – in a redemptive act of cat burglary – Lucas has to scale during the film's final scenes, to find the 'grail' Parry seeks. **➻ Jez Conolly**

Directed by Terry Gilliam
Scene description: The Red Knight and the steps of 'Camelot'
Timecode for scene: 0:40:53 – 0:44:10

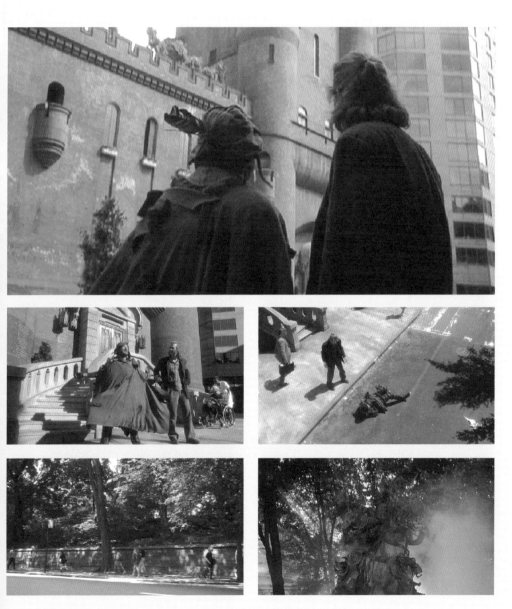

NIGHT ON EARTH (1991)

LOCATION *A yellow New York taxicab driving in various locations of Brooklyn*

THE STANDOUT VIGNETTE in Jim Jarmusch's global taxi ride portmanteau takes place in New York, in one of the iconic features of the city's landscape: a yellow cab. Since 1967 all 'medallion' taxis have, by order of New York City, been painted this distinctive hue, making official cabs instantly recognisable. East German former-clown Helmut (Armin Mueller-Stahl) is the novice cab driver, and his fare – who ultimately takes over at the wheel when Helmut proves incompetent – is the canny and exuberant YoYo (Giancarlo Esposito). The encounter is played as a fleeting friendship between two disparate but equivalently kind-hearted individuals, with YoYo seeking to assist the wide-eyed outsider with some of his New Yorker wisdom. Here they are joined by Angela (Rosie Perez), YoYo's volatile sister-in-law. As they arrive in Brooklyn, YoYo announces proudly, 'Check it out Helmut – this is Brooklyn!' By contrast, the surlier Angela dismisses it as 'a dump' and YoYo rebukes her for deriding their neighbourhood. As he drives away – in the wrong direction – Helmut reflects that Angela and YoYo, despite their tempestuous relationship, are a 'nice family'. The vignette's final moments bring into sharp, poignant focus just how lost and alone Helmut is in the Big Apple. He weaves chaotically through unfamiliar streets, flanked by sirens and appears utterly bewildered. His closing words are the iconic 'New York, New York,' but they are delivered suffused with the weight of his woes. •*Emma Simmonds*

(Photo © John Berra)

Directed by Jim Jarmusch
Scene description: Helmut and YoYo part company in Brooklyn
Timecode for scene: 0:45:47 – 0:51:26

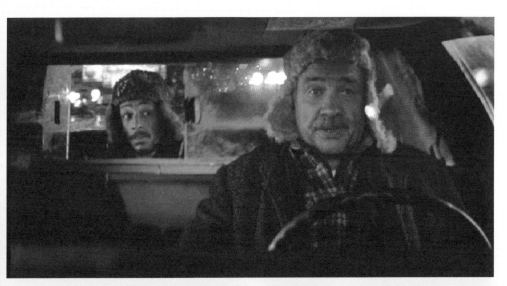

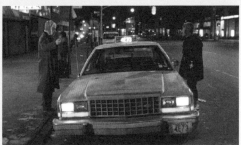

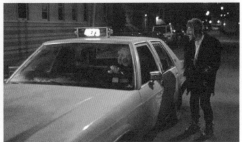

MALCOLM X (1992)

LOCATION *A podium next to the Apollo Theater, 253 West 125th Street, Harlem*

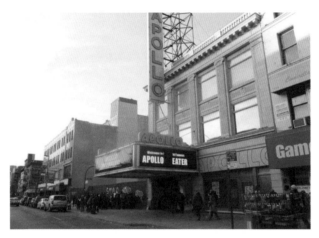

MALCOLM X is Spike Lee's powerful story of the slain Muslim civil rights leader. Based on the *Autobiography of Malcolm X*, as told to Alex Haley, the film follows Malcolm Little through his epic transformations: from life as a child of a preacher; life as a foster child in a boarding school; involvement with small-time gangsters; prison; the Black Nationalist Nation of Islam; life as a member of the greater community of Muslims; to his assassination and his legacy. Much of the film takes place in Harlem, New York, and many of its most important scenes take place in the presence of the famed Apollo Theater, including this, the famous, 'We've been had... hoodwinked... bamboozled...' speech. This century-old Apollo Theater provides an important source of New York's history of artistic richness along with the other famous theatres – Metropolitan Opera House, Radio City Music Hall, Carnegie Hall – yet, because of cultural preferences, it is often placed in our consciousness on a less sophisticated plane. We find the same practice happening with Malcolm X, when many contrast him with the more lauded Martin Luther King Jr. But with the story of Malcolm and Martin we find a parallel with the story of the Apollo and the Met, Radio City and Carnegie. Each of these is a precious brick in a larger edifice of American life; each person and each theatre targets, or targeted, different audiences. And perhaps without these men and without these theatres our lives today would be poorer.
❖Omer M. Mozaffar

Directed by Spike Lee
Scene description: Malcolm speaks outside the Apollo Theater
Timecode for scene: 1:52:00 – 1:53:55

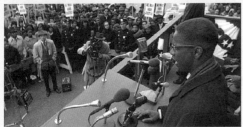

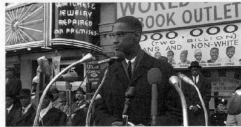

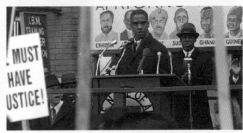

MEAN STREETS

Martin Scorsese's New York

Text by
WAEL
KHAIRY

THERE IS NO SUCH THING as seeing New York through Martin Scorsese's eyes: Scorsese merely projects the light detected by the warped eyes of his lonely protagonists. The signature, light-reflecting visual approach he uses to showcase New York City is evident in most of his films, but varies in significance and meaning from one picture to the next. The camera sends the characters' distorted perspectives directly into our brains. We have no choice: we are forced to breathe the air, gaze through the pupils, experience and feel the city environment by slipping into the shoes of twisted protagonists – the shoelaces tightly bound by Scorsese himself.

This smooth and seductive approach is evident in Scorsese's most prominent New York-based works: from the gritty realism in

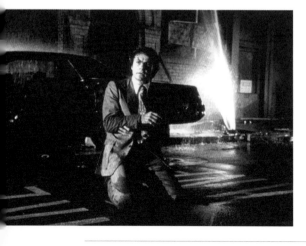

Mean Streets (1973), *Taxi Driver* (1976), *Raging Bull* (1980), *The King of Comedy* (1982) and *Goodfellas* (1990); to the exaggerated portrayal of the city in *New York, New York* (1977) and *Gangs of New York* (2002); to the hallucinatory, bizarre perception of the city in *After Hours* (1985) and *Bringing Out the Dead* (1999). Even though most of Scorsese's films are set in New York, each picture is unique in that each time we look at the city through a different window, with a vivid subject standing in front of that window. Each time, we see the New York they see and we see them seeing it.

Taxi Driver is perhaps Scorsese's most compelling film and exemplifies this double perspective. Both the audience and Travis Bickle (Robert De Niro) can't help but feel repelled by the filthy inhabitants that lurk at every dark corner and alley in the streets of New York:

'All the animals come out at night – whores, skunk pussies, buggers, queens, fairies, dopers, junkies: sick, venal. Someday a real rain will come and wash all this scum off the streets. I go all over. I take people to the Bronx, Brooklyn. I take 'em to Harlem. I don't care. Don't make no difference to me. It does to some. Some won't even take spooks. Don't make no difference to me.'

This repulsive voice-over is accompanied by windshield shots that sample the population mentioned. We see close-ups of Bickle's sharp eyes maintaining focus on the pedestrians while the yellow cab glides through the

and clubs as the backdrop and, as with most of his films, the external environment has an internal effect on our protagonist.

In a memorable, signature, slow motion sequence, we see Charlie's eyes fixed on the sight of Johnny Boy (Robert De Niro) entering the bar with two girls under his arms. Johnny Boy smiles, flirts and greets others while Charlie simply watches him. In another scene, Charlie goes wild with drinks, and the camera, fixed on him, suddenly shows us a fast motion sequence of him partying and finally blacking out. When watching *Mean Streets*, we become part of a New York gang: we engage in bar fights, quarrels and discussions. Surprisingly, *Mean Streets* was mostly shot in Los Angeles, but since the film relies mostly on indoor locations, it's impossible to suspect it was not actually shot in New York's Little Italy. That's how well Scorsese knows his city: he has the ability to convert another city into his own and convince us it's legitimate.

Decades later, Scorsese again created the city from scratch with *Gangs of New York*, for which he reconstructed a nineteenth century New York on the lot of Cinecittà Studios in Rome. In the film, we see two New York cities: the old through the eyes of Bill the Butcher (Daniel Day-Lewis) and the new, emerging, city through those of Amsterdam Vallon (Leonardo Di Caprio). Bill the Butcher and Martin Scorsese share a nostalgic affection towards an old New York slowly fading into oblivion. The director once said:

'If I continue to make films about New York, they will probably be set in the past. The "new" New York I don't know much about. It's not that I'm against contemporary film. I'm open to it in general, but I find the new colours of the city, the new Times Square, kind of shocking. I guess I'm stuck in a time warp.'

The coming-of-age tale explored in *Who's That Knocking at my Door?* (1967) is in many ways Scorsese's only semi-autobiographical film; like the characters in his first feature film, Scorsese grew up in Little Italy. At 22, the legendary director graduated with a major in Film at New York University's Tisch School of the Arts. New York is in his blood. ✦

murky clouds of steam hissing from the sewers beneath the road. Scorsese was lucky to film during a heat wave and in the midst of a garbage strike: the situation added substance to his underground vision of a nightmarish New York.

Scorsese uses slow motion to capture the effect of the city on our leading man. Travis Bickle's hostile stares and the slow motion sequences of the observed subjects show his gradual descent into madness: in a menacing neon landscape, a lonely misfit witnesses the decay of an urban city. With his preceding project, *Mean Streets*, Scorsese used similar methods to expose viewers to a very different vision of the city.

The New York City in *Mean Streets* is alive and vibrant with scenes full of energy and electricity. While, once again, the audience is exposed to the crime world of New York City, we are seeing things from a different angle. Charlie (Harvey Keitel) is a calm, small-time street gangster surrounded by hyperactive people in an out-of-control world. *Mean Streets* opens a window on the indoor activities of gangsters. Scorsese uses pool halls, restaurants, bars

The camera sends the characters' distorted perspectives directly into our brains.

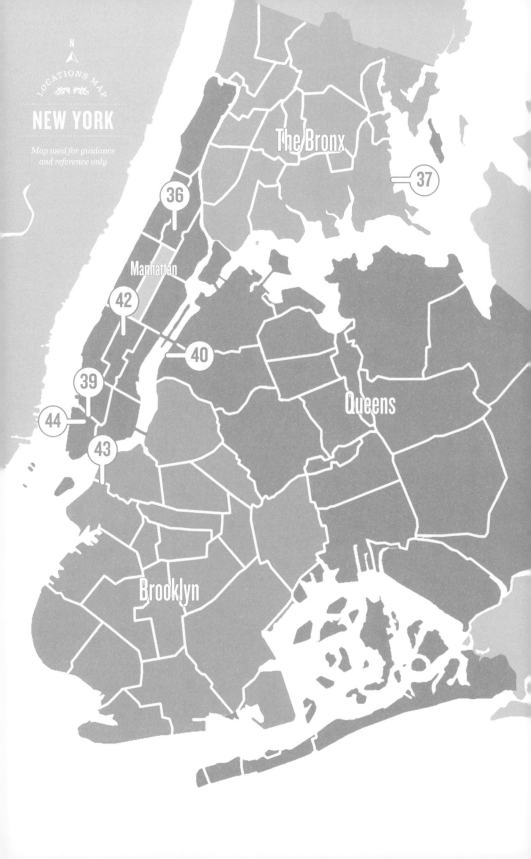

The Bronx

37

36

Manhattan

42

40

39

44

43

Queens

Brooklyn

NEW YORK LOCATIONS

SCENES 37-44

SUMMER OF SAM (1999)

Randall Avenue, Country Club District, The Bronx

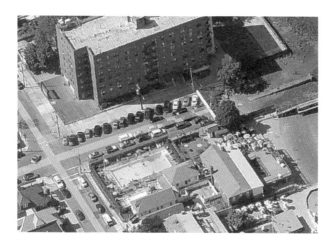

SPIKE LEE'S fictionalised account of life in New York during the famously hot summer of 1977 contains many vivid recreations of city life during the era. Set at the height of the notorious 'Son of Sam' serial killings, during which Brooklyn-born David Berkowitz killed six people and wounded seven others, Lee's film portrays New York at a time when rising unemployment, high crime levels and major power blackouts contributed to the overall decline in the city's reputation. Lee's sprawling vision of the paranoia, tribal neighbourhood cliques, fashions and dominant sociocultural attitudes of the period is exemplified by a sequence set in the predominantly Italian American area of the Bronx's Country Club district. Flanked by a community recreation area, apartments and the sea wall, the (literal and metaphorical) dead end street – where drug use, petty crime and idleness are dominant – is part playground and part battleground. (A slight geographical manipulation occurs, as the sequence was shot at the end of Randall Avenue but is shown on-screen as being Layton Avenue, though the scene's function as a representation of neighbourhood life in the Bronx remains unaffected.) During the lengthy sequence, Lee highlights how the lynch mob mentality towards outsiders that exists in some close communities can be turned inwards by those very same outside influences. He evokes the time and social climate by combining location shooting with period detail and accurate population demographics, which allows him to examine historical events – and, in turn, adds to the constantly evolving cultural mythology of New York. ⚫️**Neil Mitchell**

Above Corner of Randall Avenue and Clarence Avenue, The Bronx

Directed by Spike Lee
Scene description: Hanging out in the neighbourhood
Timecode for scene: 0:13:27 – 0:20:30

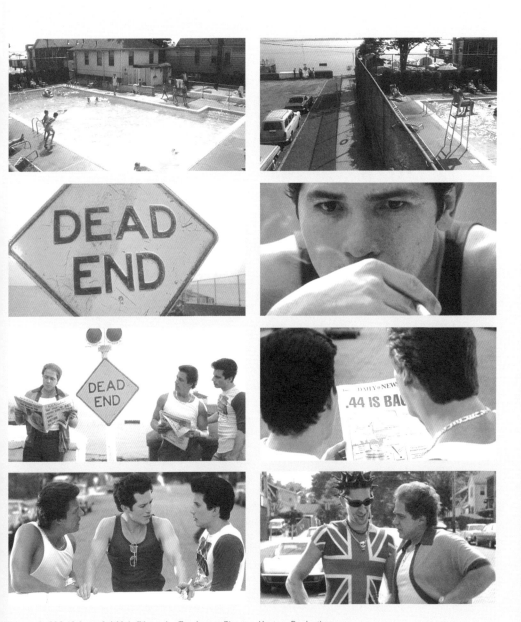

Images © 1999 40 Acres & A Mule Filmworks; Touchstone Pictures; Hostage Productions

A.I. ARTIFICIAL INTELLIGENCE (2001)

CGI created futuristic New York

SPIELBERG HAS DONE disaster before, but never quite like this: New York City flooded under hundreds of feet of water, so that only the towers of Manhattan break above the surface, groaning, wind-torn and desolate. The reason for this, we are told at the start of the film, is melting polar ice-caps. Although, really, the particulars don't matter at all. As the camera takes in the partially submerged World Trade Center, we know all we need to: this is a world where humanity is losing. And, in one of cinema's grimmest ironies, this is where the robot child, David (Haley Joel Osment), comes in search of his own humanity. He has heard the tale of Pinocchio, and fancies that there may be a magical Blue Fairy out there for him too. And so there is – only this one won't turn him from a puppet to a real boy. She is nothing more than a statue on the sea bed, a decaying remnant of an old Coney Island fairground attraction. David stares longingly at her impassive gaze for hundreds of years until the seas freeze over. It is a cruel trick, leavened only slightly by a coda – set two thousand years later – in which David discovers some of the peace he has been seeking. By then, humankind has died out completely. Our cosmic insignificance has been exposed. Little wonder why Stanley Kubrick planned to make this film before his death. **◆Peter Hoskin**

Above Manhattan skyline looking east / The Statue of Liberty (Photos © KL Yee)

Directed by Steven Spielberg
Scene description: A robot child searches for his humanity in a drowned New York
Timecode for scene: 1:31:30 – 1:50:54

Images © 2001 Warner Bros. Pictures; DreamWorks SKG; Amblin Entertainment; Stanley Kubrick Productions

25TH HOUR (2002)

LOCATION *Ground Zero, formerly the site of the World Trade Center, Manhattan*

SPIKE LEE'S most significant New York film since his breakthrough, *Do the Right Thing* (1989), revolves around the last day of freedom for Monty Brogan (Edward Norton), a convicted drug dealer about to embark on a seven year stretch in prison. Lee sets the tone of a post-9/11 New York with an opening shot of two light beams piercing the night sky where the World Trade Center once prominently stood. Later in the film, the 9/11 references intensify when Monty's friend Jacob (Philip Seymour Hoffman) picks up another friend, Francis (Barry Pepper), from a Manhattan apartment. Upon arrival, Jacob is shaken by the view: it overlooks New York's most depressing sight, Ground Zero. Frank and Jacob discuss Monty's bleak future while workers clean out the debris of the former site. Lee projects the gravity of the tragic departures of thousands of Americans through Monty's loss of freedom. 'After tonight, it's bye bye Monty,' concludes Jacob. Things won't ever be the same for them after their friend leaves for prison. The same can be said of how New Yorkers felt after the loss of the towers. Lee's stroke of genius is in mirroring the potential effect of Monty's doomed future with the weight 9/11 exerts on the shoulders of contemporary New Yorkers. He does it subtly at first, with the gloomy acreage only lurking in the background. The scene ends with Lee solidifying the connection by using a montage of the wreckage. It marks the first time a film was shot at Ground Zero.
⊷ Wael Khairy

Above Ground Zero / Architectural model of proposed site plans

Directed by Spike Lee
Scene description: 'Bye, Bye Monty'
Timecode for scene: 0:42:40 – 0:48:25

Images © 2002 25th Hour Productions; 40 Acres & A Mule Filmworks, Touchstone Pictures

KAL HO NAA HO THERE MAY BE A TOMORROW OR NOT (2003)

LOCATION *Water's Edge restaurant, overlooking Manhattan, The East River at 44th Drive, Long Island*

THE OPENING NARRATION declares: 'They say every fourth face in New York is Indian.' It makes sense, therefore, that a Bollywood blockbuster be set in the city and feature location filming. Aman (Shah Rukh Khan) has burst into the lives of Naina (Preity Zinta) and her friend Rohit (Saif Ali Khan). His dazzling zest for life has shaken Naina so strongly she has fallen in love with him. Unfortunately, it has also convinced Rohit that he should trample his fears and tell Naina he loves her. Since both he and Naina have big news, Rohit arranges to meet her at Long Island's astonishingly situated Water's Edge restaurant. (Slogan: 'The only thing we overlook is Manhattan.') Rohit has arrived early. He waits at what, given the view, is surely the restaurant's best table, with a bouquet of perfect roses, as two violinists play a romantic melody. When Naina joins him, they are too excited to talk. Finally, she exclaims, 'I love Aman!' She expects Rohit to be happy, and he must be happy. We see him crumple but Naina does not. 'He has to be insane not to love you,' he says, before telling her to go to Aman, and to give him the roses. The scene would be funny and sad if it took place at any restaurant – but set amidst the majesty of Water's Edge, its bathos borders on unbearable. Seldom has a character felt as ridiculous as Rohit in a setting as sublime as Water's Edge.
••> Scott Jordan Harris

Directed by Nikhil Advani
Scene description: *A date at Water's Edge*
Timecode for scene: 1:19:38 – 1:21:91

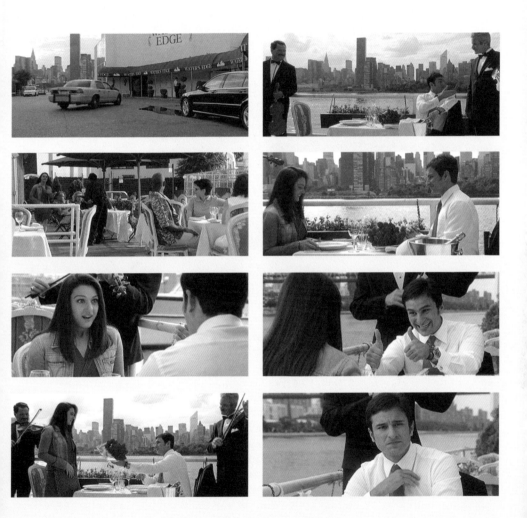

MAN PUSH CART (2005)

A classic New York push cart (on a nameless street corner in Manhattan)

WHERE ELSE IN THE WORLD do we find these shiny silver tanks that are loaded with arsenals of doughnuts, bagels, coffee, tea and cream? We find them in neither Chicago, nor Los Angeles, nor Boston, nor Atlanta, yet they decorate the streets of New York. These push carts are rolling icons of New York City. But, as Ramin Bahrani's *Man Push Cart* so carefully reveals, these carts are monuments of New York's most open secret. Peppered across the noisy jungle of machines and concrete are millions of quiet, lonely people sharing long moments of anonymous public solitude. A solitary, calm Pakistani, Ahmad (Ahmad Razvi), wakes before all others, dragging his tank through darkness and steam, across the city to his distinct, yet nameless corner. Framed by very tight shots peering through very small square windows, we watch him prepare breakfast for the city's yawning workers on their way to anonymous jobs. He hesitatingly meets a few people and ventures out of his sheltering cart, revealing that he – just like the thousands that pass him by – has a unique story. Looking at these plain, functional, mobile diners, we would never think it, but we do know that each of these carts is a chamber holding a warm, delicate New York heart. **•➤Omer M. Mozaffar**

(Photo ©Nadav Schnall)

Directed by Ramin Bahrani
Scene description: Ahmad sets up his push cart
Timecode for scene: 0:04:38 – 0:05:30

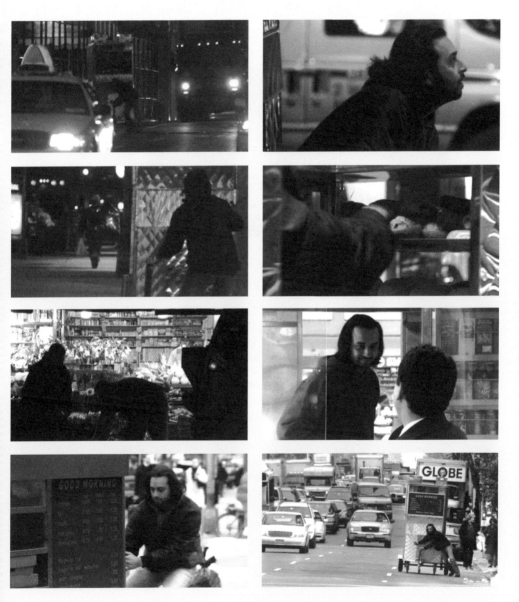

THE NOTORIOUS BETTIE PAGE (2005)

LOCATION *Times Square, Manhattan*

THE OPENING SEQUENCE of Mary Harron's affectionate and nostalgic biopic of the late 'Pin-Up Queen of the Universe', Bettie Page, is a succinct encapsulation of time, location and social climates. The spine of Harron's film (the representation of Page's years living in the city) shows New York to be the bustling and conflicted heart of American society, and the place where its cultural battles are often fought. Harron's use of Times Square, Manhattan, for the opening to the film is both factually accurate to the events portrayed and symbolically apt: if New York is at the heart of America, so Times Square is at the heart of the city. The scene evocatively combines an on-screen title reading 'New York City 1955' with archive footage of Times Square from the era, a jazz soundtrack and Harron's own sequence set within a seedy sex shop. The tone may be lighthearted, with the furtive customers browsing titles such as Wink and Beauty Parade, and the undercover policeman revealing himself with a dramatic flourish, but the portrait of the area as the vice-ridden centre of New York is true to history. Times Square was awash with sleazy strip clubs, sex shops and adult cinemas from the 1950s onwards, and which came to symbolise the city's steep decline in later decades. After major regeneration in the 1980s and '90s, Times Square has acquired contemporary respectability, but Hannon's brief portrayal of the location is a reminder of its richly diverse history. **•›Neil Mitchell**

Directed by Mary Harron
Scene description: Undercover Police raid in Times Square
Timecode for scene: 0:00:26 – 0:02:45

THE GIRL IN THE PARK (2007)

Cobble Hill Park, Cobble Hill, Brooklyn

PLAYWRIGHT AND SCREENWRITER David Auburn, best known for *Proof* (Madden, 2005), made the transition to film director with the psychological drama, *The Girl in the Park*. Largely shot in and around Brooklyn and Manhattan, the film examines the psychological trauma wrought on a marriage by a child's disappearance and, later, the re-opening of these wounds by the appearance of a troubled young woman who may or may not be Maggie, the missing daughter. Shot in Brooklyn's Cobble Hill Park, this early scene, in which Maggie vanishes, is intriguing not only for being the cataclysmic event of the film's narrative, but also for its wider psycho-geographical themes in which the physical environment is directly linked to memory and internal emotions. An everyday scene of park life, with families relaxing and children playing in the safety of an environment where nature rules, is subverted by Auburn into an ominous sequence in which the park comes to represent danger, loss and mystery. The supposed sanctuary offered by parks and recreation areas is undermined by Maggie's sudden disappearance, as autumnal leaves, wooded areas, overcast skies and criss-crossing paths offer an alternate and sinister vision of such places. For Julia (Sigourney Weaver), this location becomes the site of catastrophic loss at odds with the tranquil and restive associations of park life. New York's 1,700 parks and leisure areas give an indication of the city's size, and in Auburn's downbeat vision of New York the park is a place that can easily swallow someone up. **→Neil Mitchell**

Directed by David Auburn
Scene description: Maggie goes missing
Timecode for scene: 0:03:44 – 0:07:46

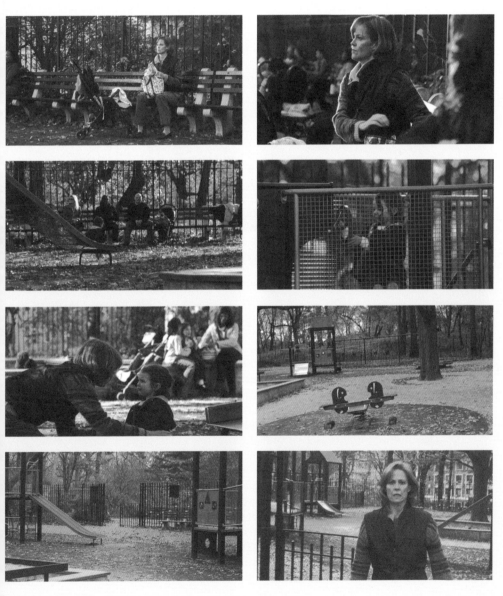

MAN ON WIRE (2008)

LOCATION Rooftop of the Twin Towers, the World Trade Center, Manhattan

ON 7 AUGUST 1974, 1,350 feet above the ground, between the rooftops of World Trade Centre Twin Towers in New York City, there was a wire. On that wire stood a man, Philippe Petit, who walked across the metal cable eight times in 45 minutes, while friends and police officers watched on both sides. It was dumbfounding, courageous, foolhardy, and undeniably mesmerizing. Thousands gathered below and watched as one man stood in the clouds, suspended in between two of the greatest man-made structures. Philippe not only walked, but also lay down, kneeled, saluted and sat, teetering at the edge of death: 'If I die, what a beautiful death – to die in the exercise of your passion.' Philippe danced on top of the world. Through an ingenious combination of original footage, re-enactments and interviews, James Marsh enthrallingly pieced together the story of a dreamer who boldly etched his footprints into the memory of New York skyline, nestled in between its crowning jewels. The inevitable knowledge of the towers' fate, combined with witnessing an unabashed realization of someone's dream – so completely, so publicly – elicits emotions that are both beautifully mysterious and deeply personal. We all dream, as children, of greatness. A vague concept for most, but not Philippe: 'I started as a young, self-taught wirewalker to dream of not so much conquering the universe, but as a boy, conquering beautiful stages.' And on one hazy, early morning in 1974, high above the New York City skyline, he did. •*Grace Wang*

Above Site of the former World Trade Center

Directed by James Marsh
Scene description: *Philippe Petit wire walks between the Twin Towers*
Timecode for scene: *01:15:35 – 01:19:00*

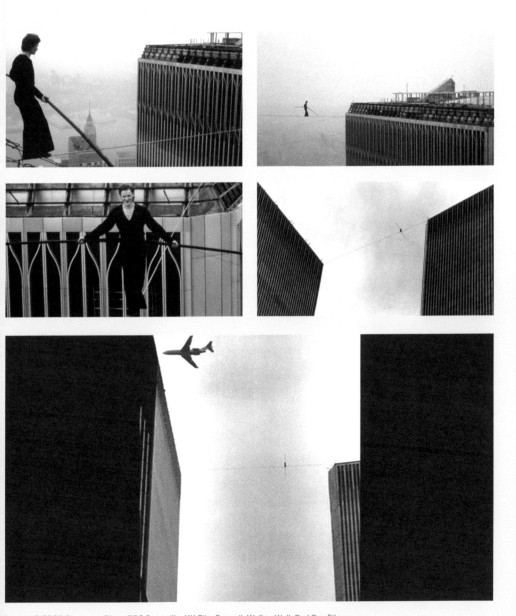

THE INNOCENTS

A Promised Land within a Promised Land

Text by
ELISABETH
RAPPE

HISTORICALLY, cities have always been a place of refuge. The city walls were a bulwark against the wilderness and the dark unknown. The city was where you went to prosper or to relish your new wealth. Even the American thirst for land never dimmed the allure of the big city. Hundreds of hopefuls flocked to New York from the family farm, dreaming of success and sophistication. It's a promised land within a promised land, and the starting point for every immigrant dream, even if that pioneer now hailed from the Midwest.

Hollywood has always loved the story of the innocent city-seeker, and never gets tired of liberally reworking Aesop's 'The

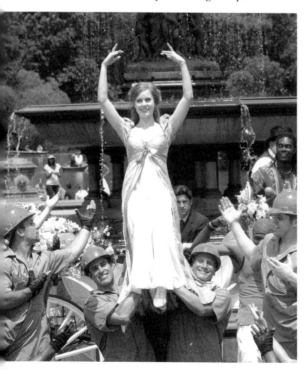

Town Mouse and the Country Mouse'. While many characters do happily remain in the city they've grown to love (as in *Romance in Manhattan* [Roberts, 1935], *Breakfast at Tiffany's* [Edwards, 1961] and *Crocodile Dundee II* [Cornell, 1988]), many flee back to the country (or at least to New Jersey, as in *It Should Happen To You* [Cukor, 1954]) to preserve their sanity and safety.

Any examination of the city innocent can almost begin and end with *Midnight Cowboy* (Schlesinger, 1969). The film is the 1970s version of the immigrant tale. Joe Buck (Jon Voight) travels to New York from Texas in the hopes of making it big in the sex trade, banking on a Gary Cooper drawl and fringed jacket to lure in ladies. He fails miserably, and winds up huddled in a condemned building with the pitiful and sickly Ratso (Dustin Hoffman). Cowboy is the dark underbelly of the immigrant experience, and the story of so many who froze or starved in decrepit tenements because they couldn't find work. Ratso has no other option but to wither and die. Cowboy refuses to dabble with hope or happy endings; the city becomes a tangible and vengeful force. New York chews up Buck and spits him out to Florida, but keeps Ratso for its own.

The cowboy of *Coogan's Bluff* (Siegel, 1968) fares a little better. Coogan (Clint Eastwood) is an Arizona sheriff's deputy tasked with extraditing a criminal named Ringerman (Don Stroud) from New York. Joe Buck wears cowboy togs as a marketing device; Coogan wears them as a talisman against the city's lousiness. When his honest cowboy boots touch the littered city streets, his disgust is palpable. Though he's inured to violence, he's appalled at the blowsy women, the kooks, the clubs, the drugs, and the very notion of a probation officer. His eyes spring wide at the

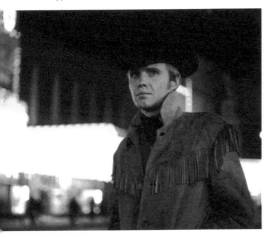

enthusiasm is that of the explorer. 'Imagine seven million people all wanting to live together,' he marvels. 'Yeah, New York must be the friendliest place on earth!' Though he finds himself bewildered by bidets, crossing signs, impenetrable crowds, and the inability to say 'G'day,' Dundee isn't emasculated by the city as others before him were. He's a man of virility in a limp and sissified city, and the film delights in constantly pitting him against homosexuals or metrosexuals. He finds the former amusing and the latter contemptible.

Even the famous knife scene is a commentary on city weaklings. Dundee (in a laughably phallic moment) proves his knife is bigger than a mugger's, and Sue (Linda Kozlowski) purrs about how she always feels safe with Mick. New York men like Richard (Mark Blum) are scared; men of the desert retain their tenacity. While Coogan finds himself slightly humbled by his city exploits, Dundee walks away bolstered in his wide-eyed opinion that New York is the friendliest place on earth, unaware his otherworldly charm opened doors, charmed a subway platform and won the girl.

Others have been as lucky in the city as Mick. In *That Touch of Mink* (Mann, 1962), Doris Day goes to New York 'from upper Sandusky' in pursuit of a husband. Her wholesome Ohio values win out over licentiousness, and she neatly dodges the fate of the despoiled and unwed that the film eagerly hangs over her. Going further, *Elf* (Favreau, 2003) and *Enchanted* (Lima, 2007) have the nerve to re-imagine *Midnight Cowboy* into tales that encourage and reward the preservation of innocence in the face of harsh city lights.

It may be that the tale of the city innocent is dead. Surely, in an increasingly sophisticated world, there are only so many naïve fish you can fling from the water and leave gasping on the streets of New York. Are Coogan, Joe Buck or Travis Bickle now reactionary or pathetic? Or is it more damaging that we cling to *Breakfast at Tiffany's* or *Enchanted*, believing that winsomeness will turn any country mouse into a city mouse? Did we shift towards *Crocodile Dundee* and *Elf* precisely because we know city glamour doesn't compensate for the gnaw of insecurity, and that we always feel like outsiders in the crowds and concrete walls of the big city? ✢

discovery of the city's bureaucracy and glaze over at the idea he has to obtain paperwork.

His hunt takes its toll. A bloodied Coogan takes a long and forlorn look across the cityscape, his eyes keep scanning for a horizon: '[I'm] trying to picture it the way it was – just the trees and the river, before people came and fouled it all up.' But, like any good animal, Coogan adapts – and he succeeds in proving his Western lore to be superior to street smarts. The film suggests New York needs more men like him, but he abandons it and his new love interest, though not without having learned something himself. As he looks out on the city one last time, he quietly shares his cigarettes with Ringerman. Like Joe Buck and Travis Bickle in *Taxi Dirver* (Scorsese, 1976) after him, he's seen the dank corners where the monsters dwell. He realizes that kindness, pity and humanity are what keep them at bay, and his small gesture suggests a reawakening of his 'country' values.

Crocodile Dundee (Faiman, 1986) happily milks both *Coogan's Bluff* and *Midnight Cowboy*, but has to go all the way to the outback of Australia to find it's innocent. Sunburnt and shirtless, Mick Dundee (Paul Hogan) visits New York on a lark, and his

Surely, in an increasingly sophisticated world, there are only so many naïve fish you can fling from the water and leave gasping on the streets of New York.

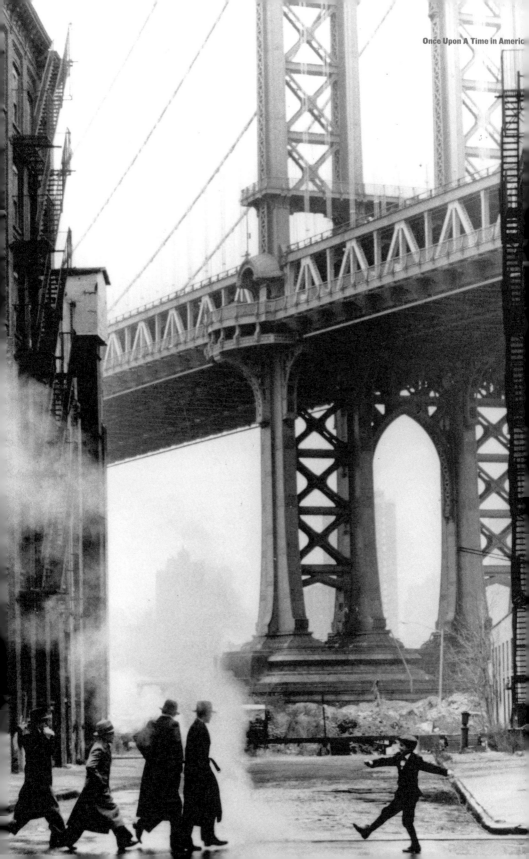

GO FURTHER

Recommended reading, useful websites and further viewing

BOOKS

The Great Movies
By Roger Ebert
(Broadway Books, 2002)

Manhattan on Film:
Walking Tours of Hollywood's
Fabled Front Lot
By Chuck Katz
(Limelight Editions, 2005)

New York:
The Movie Lover's Guide: The Ultimate
Insider Tour of Movie New York
By Richard Alleman
(Broadway Books, 2005)

Scorsese on Scorsese
David Thompson and Ian Christie (eds.)
(Faber and Faber, 1989; 1996)

Woody Allen on Woody Allen
Edited by Stig Bjorkman
(Faber and Faber, 1995, 2004)

Street Smart:
The New York of Lumet, Allen,
Scorsese and Lee
By Richard Aloysius Blake
(The University Press of Kentucky, 2005)

Projections 11:
New York Film-makers on New York
Film-making No. 11
Tod Lippy and John Boorman (eds)
(Faber and Faber, 2001)

Celluloid Skyline:
New York and the Movies
By James Sanders
(Alfred A. Knopf, 2001)

The Epic of New York City
By Edward Robb Eliis
(Coward-McCann Inc, 1966)

BOOKS (continued)

New York Vertical
By Horst Hamann
(teNeues Publishing, 2000)

ONLINE

www.nyfolklore.org
Voices – The Journal of New York Folklore

www.onthesetofnewyork.com
On the Set of New York – a thorough guide to
famous filming locations in New York City.

www.nyc.gov/film
The New York Mayor's Office of Film,
Theatre and Broadcasting.

FILMS

New York:
A Documentary Film
Directed by Rick Burns
US, 1999, colour, 600 min.

Historic Travel US – New York –
The Evolution of a Metropolis
US, 2001, colour, 130 min.
(www.a2zcds.com, 2001)

New York – First City of the World
Quantum Leap (studio)
US, 2008, colour, 60 min.

CONTRIBUTORS

Editor and contributing writer biographies

EDITOR

SCOTT JORDAN HARRIS is the editor of *The Big Picture* magazine and *World Film Locations: New York*. He writes for *The Spectator* and co-edits its arts blog, and is a contributor to many magazines, websites and journals. He has also written for several books on cinema, including the Dublin and LA volumes of the *World Film Locations* series. His blog, *A Petrified Fountain*, was named one of the world's twelve best movie blogs by *RunningInHeels.co.uk* and can be viewed at *www.apetrifiedfountain.blogspot.com*.

CONTRIBUTORS

SAMIRA AHMED is a senior correspondent and news anchor at Channel 4 News in London. She won the 2009 Stonewall UK Broadcaster of the Year award for a report on so-called 'corrective' rape in South Africa. Formerly a correspondent at the BBC for *Newsnight*, *The Today Programme* and *BBC News*, and an anchor for the BBC News channel and Deutsche Welle TV in Berlin, a highlight of her 20-year career was being the BBC's Los Angeles Correspondent, which fuelled her love of film. She's reported on everything from terrorist attacks to the OJ Simpson case, but specialises in writing and broadcasting about culture, especially cinema, for outlets including *The Spectator* magazine, and *The Guardian* and *The Independent* newspapers. She has a special thing for Westerns. Her favourite New York films are *On The Town* and *Crossing Delancey*.

JOHN BERRA is a lecturer in Film Studies at Nanjing University. He is the author of *Declarations of Independence: American Cinema and the Partiality of Independent Production* (2008), and the editor of the *Directory of World Cinema: American Independent* (2010) and the *Directory of World Cinema: Japan* (2010). John has also contributed chapters to *The End: An Electric Sheep Anthology* (2011) and *The Companion to Film Noir* (2012), while his film criticism has appeared in *Electric Sheep*, *Film International*, *The Big Picture* and *VCinema*.

JEZ CONOLLY holds an MA in Film Studies and European Cinema from the University of the West of England, and is a regular contributor to *The Big Picture* magazine and website. Jez comes from a cinema family; his father was an over-worked cinema manager, his mother an ice-cream-wielding usherette and his grandfather a brass-buttoned commissionaire. Consequently, he didn't have to pay to see a film until he was 21, and having to fork out for admission still comes as a mild shock to this day. After many years soaking up anything and everything on-screen he started to exercise a more critical eye in the 1980s, became obsessed with David Lynch movies and grew a goatee beard to give him something to stroke when patronising art house cinemas. The rest is cinematography. In his spare time he is the Arts and Social Sciences & Law Faculty Librarian at the University of Bristol.

DAVID FINKLE is a freelance journalist based in New York City. Over several decades he has written about film, theatre, music, books, art and dance for many publications, including the *New York Times*, *The Village Voice*, *The New Yorker* and *The Nation*. At the moment, he is the senior dramatic critic at the theatre website *TheaterMania.com* and is a regular contributor to *The Huffington Post*.

PETER HOSKIN is a journalist at the London-based magazine *The Spectator*. He graduated with a first-class degree in Politics, Philosophy and Economics from the University of Oxford in 2006, and then spent a brief period in a think-tank, before joining *The Spectator* as online editor in 2008. He writes on politics, literature and film, both for his home publication and other publishers such as the *Daily Telegraph*, *The Daily Beast* and *the British Film Institute*. Peter's favourite New York-set film is *The Roaring Twenties*, although that's subject to change.

WAEL KHAIRY is an Egyptian film critic writing for *C Mag*, Egypt's first English language magazine dedicated entirely to film. He is also one of Roger Ebert's Far Flung Correspondents and was named by the legendary film critic as a contributor to the golden age of film criticism in a *Wall Street Journal* article. Besides his website, *www.cinephilefix.wordpress.com*, and the *Chicago Sun-Times* blog, Wael also regularly writes for *The Spectator*'s arts blog. He was born on 29 February 1988 in London but moved to Cairo shortly after birth. His passion for cinema started at a very young age when the viewing of *Jaws* triggered a movie-watching frenzy, and he has been reading about film ever since. Wael Khairy graduated from the American University in Cairo with a major degree in Communication of Media Arts, a minor in Business Administration and another minor in Film, which he completed at UCLA.

SIMON KINNEAR is a freelance journalist in film and television. He is a regular contributor to *Total Film*, and has also written for *Clothes on Film*, *SFX* and *Doctor Who Magazine*. A graduate of the British Film Institute/Birkbeck College London's MA in Cinema and Television Studies, Simon's career in film journalism didn't begin in earnest until he was selected as a finalist in *Empire* Magazine's 'Thunderdome' competition for new writing talent. His blog can be viewed at *kinnema.blogspot.com*.

MICHAEL MIRASOL is a Filipino independent film critic who has been writing about films for the past 11 years. He briefly served as film critic for *The Manila Times* and now writes occasionally for *Uno Magazine* and his blog, *The Flipcritic*, which can be seen at *www.michaelmirasol.com*. Last year, he was named by Roger Ebert as one of his Far Flung Correspondents, and continues to contribute written and video essays on film.

CONTRIBUTORS

contributing writer biographies (continued)

NEIL MITCHELL is a freelance film critic, writer and editor based in Brighton, East Sussex. He graduated as a mature student from the University of Brighton with a BA in Visual Culture. Having contributed to various editions of Intellect's *Directory of World Cinema* series, he has taken on the role of co-editor for the British volume. His interest in all aspects of cinema has led to a growing fascination with British cinema in particular, which led to him editing the London volume of the *World Film Locations* series. He writes regularly for *The Big Picture* magazine, *The Spectator*'s arts blog and *RogueCinema.com*, and occasionally for *VariedCelluloid.net* and *Electric Sheep*. See more of his writing visit *nrmthefourthwall.blogspot.com*.

OMAR P.L. MOORE is an attorney and film critic. He was born and raised in England. Omar is the founder and editor of *The Popcorn Reel*, a movie review, essay, video and celebrity interview website. The site is located at *www.popcornreel.com*. He's a member of the San Francisco Film Critics Circle and a contributing critic to the American television movie review show *Ebert Presents At The Movies*. Omar loves sports. He's also an athlete who is a big fan of Watford Football Club, the New York Knicks and the San Francisco Giants baseball team. He's lived in London and New York.

OMER M. MOZAFFAR is one of Roger Ebert's Far Flung Correspondents. He writes about film at *Shaykh Pir* (*shaykhpir. wordpress.com*). He is also a college professor teaching courses on theology, mysticism, literature, history, and of course, film. He was born in Pakistan and is based in Chicago.

ELISABETH RAPPE is a film journalist living in Denver, Colorado. She studied History and English Literature at Metropolitan State College of Denver, and had her heart set on studying Old English poetry in graduate school until she decided she was really too distracted by movies old and new to ever give a good lecture. She began her career writing for *Cinematical*, where she became known for her weekly column, 'The Geek Beat'. She was featured on NPR's *The Wrap* for her insights into comics and geek culture, and is a proud member of the Alliance of Women Film Journalists. After parting ways with *Cinematical* in 2010, she has become a regular contributor to *Film.com*, *CHUD* and *The Spectator*'s arts blog. She spends her off-time with her pug, Elliot, video games and Clint Eastwood movies.

EMMA SIMMONDS is a London-based freelance journalist, editor and copywriter specialising in film and television. She graduated in 2003 from the University of Kent with a BA (Hons) in Film Studies, and went on to complete a BFI/*Sight and Sound* Postgraduate Certificate in Film Journalism in 2005. Emma has since contributed to numerous publications, including *Little White Lies*, *The Arts Desk*,

PopMatters, *Electric Sheep*, *The Big Picture*, *Roof* and *The Spectator*'s arts blog. Particular areas of interest include performance, the horror film, French cinema and the films of Alfred Hitchcock.

GRACE WANG has a deep passion for cinema and writes related musings, alongside poetry, short stories and photography on her website, *Etheriel Musings* (*etheriel.wordpress.com*). She is one of Roger Ebert's Far Flung Correspondents and regularly contributes to *rogerebert.com*, *The Spectator*'s arts blog and various online publications. Grace was the Social Media Coordinator for the 2010 Toronto International Film Festival, and is returning as a Programming Associate for the 2011 Festival. She recently embarked on a two-month trip in China exploring the Chinese cinema scene. Her related column, 'Etheriel Musings: A Journey in China', can be found on *rogerebert.com*. Grace is fluent in Mandarin and Cantonese, and a beginner in Japanese and Spanish. In her spare time, she practices as a lawyer, daydreams constantly, and hops on planes and trains as much as possible. She currently resides in Toronto, Canada.

FILMOGRAPHY

A comprehensive list of all films mentioned or featured in this book

25th Hour (2002)	101, 106, 107
42nd Street (1933)	9, 14, 15
2012 (2009)	25
After Hours (1985)	98
A. I. Artificial Intelligence (2001)	25, 101, 104, 105
Alice in the Cities (1974)	45, 52, 53
American in Paris (1951)	6
An American Tail (1986)	24
Annie Hall (1977)	60, 63, 64, 65
Around The World in 80 Days (2004)	24
Best of Everything, The (1959)	27, 32, 33
Black Caesar (1973)	45, 48, 49
Born Yesterday (1950)	30
Breakfast at Tiffany's (1961)	7, 27, 36, 37, 118, 119
Bringing Out the Dead (1999)	98
Broadway Danny Rose (1984)	63, 72, 73
Cloverfield (2008)	25
Coogan's Bluff (1968)	118, 119
Crocodile Dundee (1986)	119
Crocodile Dundee II (1988)	118
Day After Tomorrow, The (2004)	25
Deep Impact (1998)	25
Deluge (1933)	24
Do the Right Thing (1989)	81, 86, 87, 106
Docks of New York, The (1928)	42
Dog Day Afternoon (1975)	45, 56, 57
Easy Rider (1969)	79
Elf (2003)	119
Enchanted (2007)	118, 119
Escape from New York (1981)	24, 25
Fisher King, The (1991)	81, 92, 93
Flaming Creatures (1963)	79
Flower Thief, The (1960)	79
Force of Evil (1948)	42, 43
French Connection, The (1971)	27, 40, 41, 43
Gangs of New York (2002)	43, 98, 99
Ghostbusters (1984)	63, 74, 75
Ghostbusters II (1989)	25
Girl in the Park, The (2007)	101, 114, 115
Godfather, The (1972)	45, 46, 47
Godfather Part II, The (1974)	24
Godfather Triology, The	46
Goodfellas (1990)	98
Guns of the Trees (1961)	79
Immigrant, The (1917)	24
Independence Day (1996)	25
It Should Happen To You (1954)	27, 30, 31, 118
Jazz Singer, The (1927)	9, 10, 11
Kal Ho Naa Ho (2003)	101, 108, 109
King Kong (1933)	6, 9, 16, 17
King of Comedy, The (1982)	98
Lost Weekend, The (1945)	9, 18, 19
Malcolm X (1992)	81, 69, 97
Manhattan (1979)	60, 63, 68, 69
Man on Wire (2008)	101, 116, 117
Man Push Cart (2005)	101, 110, 111
Match Point (2005)	61
Mean Streets (1973)	98, 99
Men in Black 2 (2002)	25
Midnight Cowboy (1969)	118, 119
Miracle on 34th Street (1947)	9, 20, 21
Mo' Better Blues (1990)	81, 92, 91
Naked City, The (1948)	9, 22, 23, 43
New York, New York (1977)	98
Night on Earth (1991)	81, 94, 95
Notorious Bettie Page, The (2005)	101, 112, 113
On the Town (1949)	27, 28, 29
On the Waterfront (1954)	42, 43
Pickup on South Streert (1953)	43
Pillow Talk (1959)	27, 34, 35
Planet of the Apes (1968)	25
Play It Again, Sam (1972)	61
Port of New York (1949)	43
Proof (2005)	114
Pull My Daisy (1959)	79
Raging Bull (1980)	98
Remo Williams: The Adventure Begins (1958)	25
Romance in Manhattan (1935)	118
Rosemary's Baby (1968)	27, 38, 39
Saboteur (1942)	24
Saturday Night Fever (1977)	63, 66, 67
Scorpio Rising (1964)	79
Serpico (1973)	45, 50, 51
Shadows (1959)	78, 79
Sid and Nancy (1986)	63, 76, 77
Speedy (1928)	9, 12, 13
Street Scene (1931)	6
Summer of Sam (1999)	101, 102, 103
Superman IV (1987)	25
Take the Money and Run (1969)	61
Taking of Pelham 123, The (1974)	45, 54, 55
Taxi Driver (1976)	45, 58, 59, 98, 119
That Touch of Mink (1962)	119
Titanic (1997)	24
Vicky Cristina Barcelona (2008)	61
Wall Street (1987)	81, 82, 83
Warriors, The (1979)	63, 70, 71
When Harry Met Sally (1989)	81, 88, 89
Who's Knocking at my Door? (1967)	99
Working Girl (1988)	81, 84, 85
X-Men (2000)	25

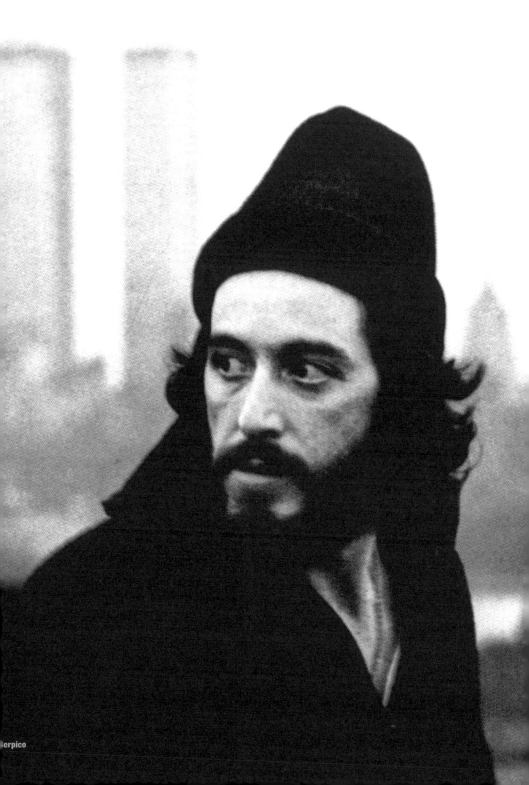

WORLD
FILM
LOCATIONS
EXPLORING
THE CITY
ONSCREEN

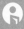

www.intellectbooks.com